IMAGES
of America

CARNEGIE

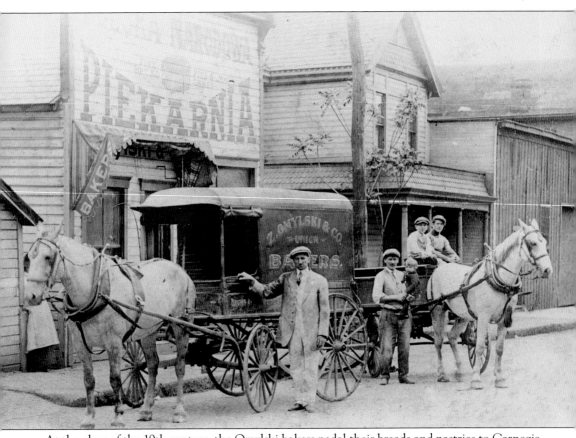

At the close of the 19th century, the Omylski bakers pedal their breads and pastries to Carnegie customers in their horse-drawn cart, pictured here on Third Avenue, around 1900.

IMAGES
of America

CARNEGIE

Sandy Henry
for the Historical Society of Carnegie

ARCADIA
PUBLISHING

Published by Arcadia Publishing
Charleston SC, Chicago IL, Portsmouth NH, San Francisco CA

Printed in the United States of America

Library of Congress Catalog Card Number: 2006922348

For all general information contact Arcadia Publishing at:
Telephone 843-853-2070
Fax 843-853-0044
E-mail sales@arcadiapublishing.com
For customer service and orders:
Toll-Free 1-888-313-2665

Visit us on the Internet at www.arcadiapublishing.com

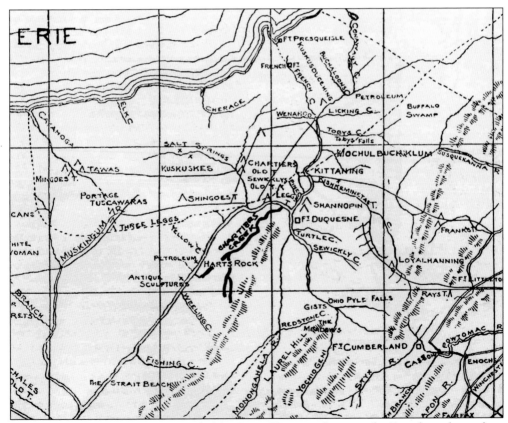

This 1756 map depicts the area settled by Peter Chartier, the son of a French trader and an American Indian woman. Chartier built a trading post around 1750 on the creek that later came to bear his name. It has since been known as Chartiers Creek.

CONTENTS

ACKNOWLEDGMENTS

I wish to express my appreciation to the following individuals who have so generously aided in the completion of this book:

To my editor, Erin Vosgien, who was never more than an Instant Message away. Your support and encouragement made *Carnegie* a rewarding project.

To Marcella McGrogan of the Historical Society of Carnegie, whose passion for preserving the history of my hometown was contagious. You are a tireless example of selfless giving and an amazing inspiration.

To the unflappable Jerry Grefenstette, who spent countless hours preparing and scanning our photographs. This book could not have been possible without your talents and commitment.

To Paula Rutkowski, whose humor and dedication were immeasurable.

To my aunt, Rita Kumpf Hareza, who fostered in me a deeper appreciation for those who have gone before.

There are various historians whose works have been enormously helpful in my research: Aggie M. Justus, Rev. Jim Garvey, V. Robert Agostino, Dr. Sam Astorino, Dorothy Drensen, Dan McGrogan, Dennis and Jeanne DeValeria, Marty Wolfson, Jack Kavanagh, Norman L. Macht, Helen Whaley, and the Diamond Jubilee Souvenir Book Committee.

The following individuals and volunteers have made generous contributions to the Historical Society of Carnegie or to our project: Bill Henry, Carol Dlugos, Mike Buzzelli, Irene Sekelik, Cecilia Bauman, Arlene Tarasovich, Viola Partee, Ellen R. Hultz, Haddie Hall, Tom Kidder Jr., Joe Stafford, Frank Stingone, Jack Polaritz, Karen Wilmus, Hon. John G. Brosky, Rose Brosky, Chuck McCartney, Janice Donley, H. Edward Donley Jr., Leslie Wagner Blair, the Steel Heritage group, *The Signal Item*, and the *Pittsburgh Post-Gazette*.

Finally, this project could never have been possible without the generosity of all who have donated photographs and scrapbooks in an effort to record and preserve the history of Carnegie. I extend my most sincere gratitude.

Note: A devastating flood in September 2004 and a fire in October 2005 resulted in the destruction of some of the historical society's collection, and tracing the history of many old photographs was a challenge. I sincerely apologize for any omission or oversight that may appear herein and take full responsibility for this historical work.

—Sandy Henry, March, 2006

INTRODUCTION

In the mid-1700s, an American Indian paddling his canoe down the Ohio River came upon a sprawling area, which he named the Valley of Plenty. This rich valley encompassed lush farmland that would later become Carnegie and neighboring Bridgeville. During this period, a handful of log homes dotted the valley situated on a creek named for its earliest settler of record, Peter Chartier, sometimes spelled "Shartier" or "Chartiers." Peter was born to a French trader father and an Indian mother. And like his father, Martin, Peter married a Shawnee woman, became a licensed trader, and was fluent in French, English, Shawnee, and Delaware.

The Delawares had moved into the Ohio Valley in the 1720s, and both French and English authorities sought Peter Chartier's help in driving the Delawares out of the area. Records indicate that ultimately Chartier demonstrated his allegiance by accepting a military commission from the French. In May 1745, British authorities declared Chartier a traitor.

In 1750, Peter Chartier built a trading post on the creek that would come to bear his name. Chartiers Creek divided the parcels of land that comprised the First Ward (Chartiers) and the Second Ward (Mansfield). Chartiers was settled on the west side of the creek by Col. John Campbell and at one time was known as Campbellsburg. The colonel sold his holdings in 1806 to John Cubbage. Legend has it that following the sale of the land, Campbell went to Kentucky with Daniel Boone.

The Chartiers region was incorporated as a borough in September 1872. James and John Bell, sons of Robert Bell, are reported to be the "first permanent, white settlers" of what is now Carnegie. Other prominent families in the valley included the Cubbages, Doolittles, Rosses, and Ewings. The first burgess of Chartiers was William Hill.

On the east side of the creek was Mansfield, also incorporated in September 1872. Now known as the Second Ward of Carnegie, nearly all of this land was owned by Mansfield B. Brown, the son of James Brown of County Cavan, Ireland. The first burgess of Mansfield was J. V. Rowland.

In February 1894, the heated topic for discussion was the merger of the Chartiers and Mansfield Boroughs. Rev. Charles Knepper, publisher of the *Mansfield Item*, championed the cause. His newspaper ran many editorials and solicited names for the new town. At the top of nearly every list was steel magnate and philanthropist Andrew Carnegie.

Residents petitioned Carnegie to offer financial assistance, and he promised to respond generously if the new town were named for him. Thus, on March 1, 1894, the town of Carnegie was founded. The town's famous benefactor kept his promise by purchasing a large parcel of land for a majestic new library and endowed it with gifts totaling more than $100,000.

In 1901, editor Knepper declared that the "new century will see our town a large city." He was convinced, as were many others in Carnegie, that their new town would become an urban center and was poised for tremendous growth of commerce, industry, and education. The future looked bright.

Principal industries in the ensuing years included steel mills, coal mines, and railroads. The railroads were vital to the community often referred to as "Little Pittsburgh" and transported coal, fuel, and freight in addition to passengers. The schools were heralded as among the best in the state. And community life in Carnegie was family focused.

Superior Steel Company was the largest industry in the small town, and many generations of families worked there. The mill opened in 1893 and sat on 15 acres of land. It began with 100 employees who became a family in the truest sense, organizing picnics and baseball games. Pirates shortstop Honus Wagner worked at Superior when he was not playing ball. The mill workers even formed their own football team.

Superior's first order was for a single coil of cold rolled strip. By 1895, the first hot mill opened, and business was booming. Superior Steel was renowned for quality workmanship and handling specialty orders. The company celebrated its highest peacetime sales record in 1950.

Throughout the first half of the 20th century, other Carnegie businesses thrived as well. Main Street was lined with every sort of retailer, from bakeries to banks, movie houses to mortuaries. There were two dozen churches in town, and despite the numerous floods that threatened homes and businesses each time Chartiers Creek overflowed its banks, Carnegie's faithful counted themselves blessed.

But the tides began to turn in the mid-1950s. On August 6, 1956, a blinding downpour of rain fell on Carnegie, and the waters rushing down Main Street rose to three feet. The estimated damage from the devastating flood was $6.2 million.

The following August, a proposed merger between Superior Steel and Copperweld Steel Company appeared inevitable. The move was met with mixed emotions but did not result in personnel changes. A restructuring occurred, new equipment and methods were implemented, and the company rolled along. Sadly, however, foreign competition ate into the new company's profits. And on March 2, 1962, Superior Steel was forced to close its doors for good.

Not long after the 1956 flood, plans were drawn up for a new Flood Control Project, which was part of a larger redevelopment initiative. The two plans converged in 1965.

Demolition of homes on Jane Street began in April of that year. Most of those displaced were African American families, many of whom then moved to Pittsburgh's Hill District. The African American population was nearly cut in half. Mansfield Boulevard replaced Jane Street and was called the Jane Street Bypass.

Finally, in 1972, Gateway Engineering undertook the task of flood control and dredged Chartiers Creek. They also removed sewer pipes, realigned parts of the creek, and lined the banks with concrete walls.

In June 1972, the Flood Control Project was tested when Hurricane Agnes tore through the area. The walls held fast, and the storm and heavy rain resulted in no flooding. In fact, Carnegie suffered no significant flooding until September 2004, when the waters of Hurricane Ivan devastated homes and businesses and resulted in one death.

The flood in 2004 signaled the end for many long-standing businesses in Carnegie, including Eagle Drug. Several churches were damaged beyond repair and were closed. So one might wonder what it is about Carnegie that causes residents to stay.

Perhaps it is the fact that many are tied to the area by lengthy family roots. Descendants from the original settlers abound in the first and second wards. Maybe it is the small-town charm, the good schools, the Victorian architecture, and the churches. Or maybe it is all of these things that entice some 8,000 citizens in this 21st century to call Carnegie home.

At the time of this writing, many families were still struggling to rebuild lives that were nearly destroyed in the aftermath of the 2004 hurricane season. But their resilience, faith, and pride in their community sustain them.

This book was made possible by the generosity of those residents who have shared their family treasures, photographs, albums, and other cherished mementos with the Historical Society of Carnegie. And we are pleased to now share them with you.

One

FOUNDERS, FAMILIES, AND A FAMOUS BENEFACTOR

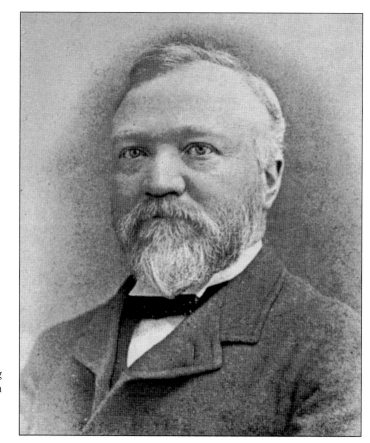

Andrew Carnegie, a Scots immigrant, was a financier, industrialist, and philanthropist. In 1894, the boroughs of Mansfield and Chartiers were consolidated, and a new name for the area was solicited. Carnegie promised to endow the town with a generous gift if it was named for him. Thus the town of Carnegie was born. Andrew Carnegie kept his promise by purchasing a large parcel of land for a majestic new library and endowed it with gifts of more than $100,000.

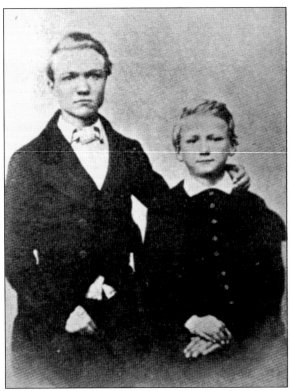

Andrew Carnegie was born in Scotland in 1835. Here a teenage Andrew posed with younger brother Thomas Morrison Carnegie in 1851. The Carnegie family settled in Pittsburgh in 1848, where Andrew secured work as a "bobbin boy" in a textile mill.

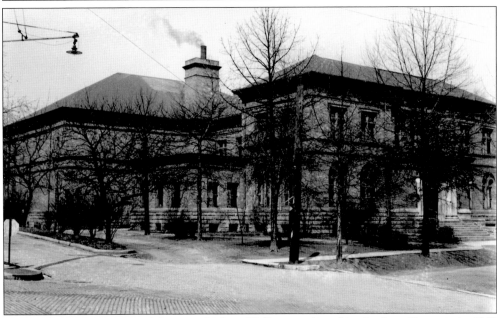

The Andrew Carnegie Free Library and Music Hall was endowed by Andrew Carnegie in 1901 and is the only Carnegie Library to bear his first name. The library opened to the public on May 1, 1901, and the first book checked out was *Triumphant Democracy*, authored by Carnegie himself. The grand music hall seats more than 500, and beneath each of the seats is a framed shelf designed to stow a hat.

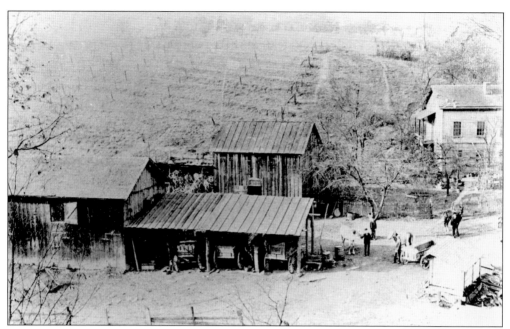

The Silk Farm, formerly the location of the Wabash Round House, is one of the oldest settlements in the area. The Silks purchased the farm from the American Indians around 1800. Left behind was an infant boy, later named Tom, who was raised by the Silks with their other children. Tom later married and raised his own family in Carnegie.

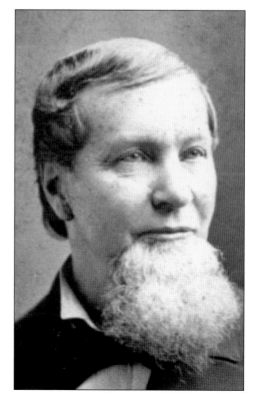

Mansfield Banton Brown (1816–1883) settled the town of Mansfield on land his father, James, purchased in the Chartiers Valley. Mansfield Brown was active in the First Presbyterian Church, as well as in several lucrative businesses, including the Plank Road Company, of which he was president, and the Panhandle Railroad, where he served as director.

11

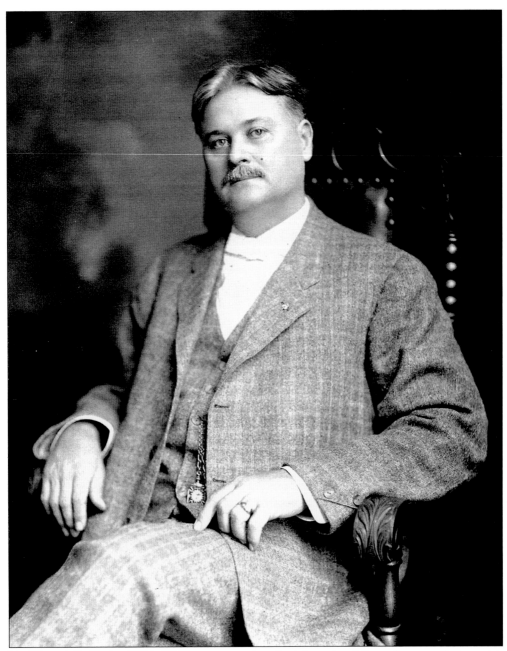

Dr. Edward G. Husler (1854–1915) was a popular physician who delivered many of Carnegie's babies. In addition to making house calls and tending to Carnegie's sick, Husler was active in the community and civic affairs. He served as burgess in the early 1900s and built the Husler Building, the home of the Carnegie Historical Society, in 1896. The Husler was one of several adjoining buildings that sustained significant damage in the flood of 2004. In October 2005, a fire destroyed several of the buildings on the East Main Street block. Although Husler's building sustained some fire and water damage, the stout old structure was the only building to survive the blaze.

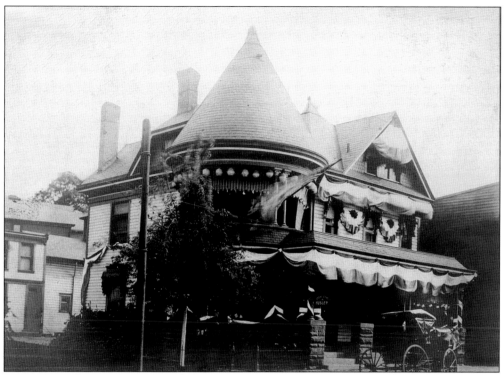

Dr. Husler's office was located inside his residence at 32 East Main Street. Here the elegant house is decorated for Old Home Week in 1908.

Cora Aston was the first child born in the town of Carnegie. She was delivered by Dr. Husler.

The James Bell farm and homestead was built in 1772, more than 100 years prior to the merging of Mansfield and Chartiers. Seven members of the Bell family married seven members of the Kearns family and were among the earliest settlers in the area.

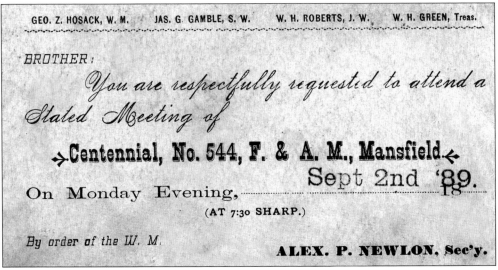

GEO. Z. HOSACK, W. M. JAS. G. GAMBLE, S. W. W. H. ROBERTS, J. W. W. H. GREEN, Treas.

BROTHER:

You are respectfully requested to attend a Stated Meeting of

→**Centennial, No. 544, F. & A. M., Mansfield**←

On Monday Evening, ——— Sept 2nd '89. 18

(AT 7:30 SHARP.)

By order of the W. M.

ALEX. P. NEWLON, Sec'y.

Members of the Centennial Board convened for a meeting on September 2, 1889. Alex P. Newlon was the board secretary.

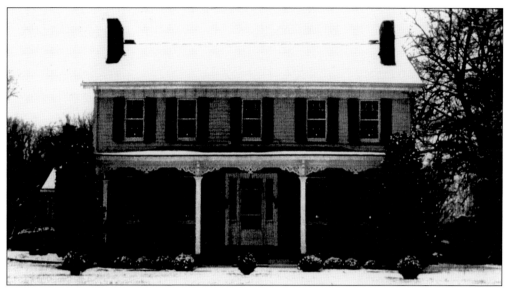

This grand residence was built in 1850 for Henry Smyth, who lived there with his family until 1886. At that time, he sold the Georgian-style home to George B. Forsythe. Long known as the Forsythe Home, the house still stands on Forsythe Road in Carnegie, with George's descendants Wanda and Vic Clay proudly maintaining the family homestead.

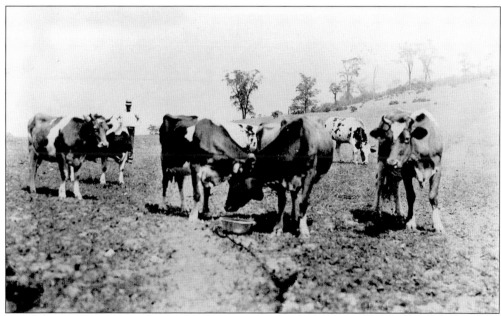

The Forsythe Home sat on the family's 90-acre farm. Carnegie Park was once part of the Forsythe corn field, and the property boasted a large chicken house and pasture. Carnegie had its own version of a cattle drive during the 1920s when cattle from the Forsythe farm were driven down Chestnut Street to be slaughtered at the Abbott Ice and Packing plant.

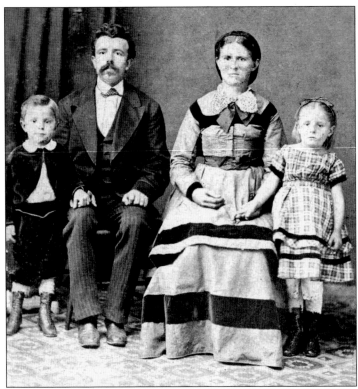

John W. Kumpf and his wife, Caroline Abbott-Kumpf, pose with two of their seven children, William and Ida, around 1870. Caroline's family owned the Abbott Ice and Packing Company. John and Caroline are this author's great, great grandparents. The Kumpf family home still stands on Chestnut Street.

John Kumpf and his granddaughter Catherine are pictured here around 1925. Kumpf fought in the Battle of Gettysburg and later served as a founding member of Carnegie's First Council and the Carnegie Centennial Volunteer Fire Company. He was "Carnegie's Oldest Resident" when he died in 1929 at age 92.

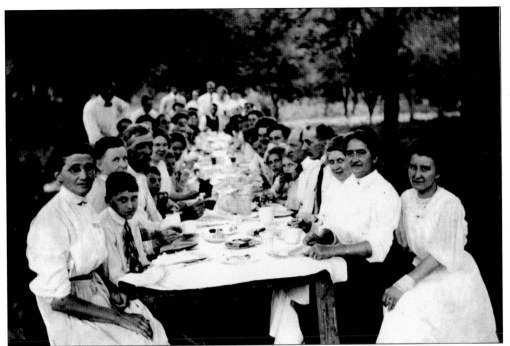

In 1910, Edward Abbott was the president of the Abbott Ice and Packing Company. Here the Abbott family gathers for a picnic. Standing at left is Albert, son of Edward and Elizabeth Jacob Abbott. Albert drove the company's delivery wagon and later the delivery truck for the packing plant.

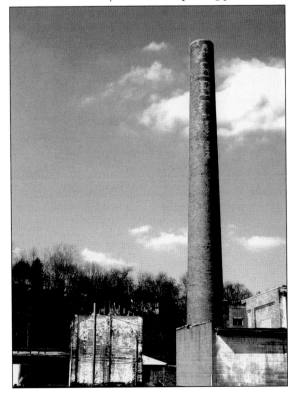

The Abbott plant's smokestack has been a familiar Carnegie landmark for more than 100 years. The name Abbott is integrated into the brickwork.

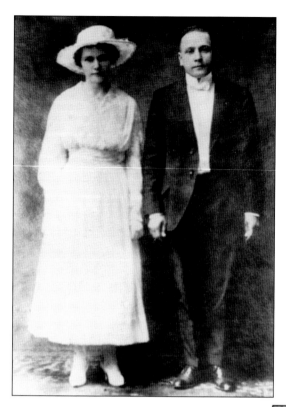

Dr. Charles E. Herman and Louise Daube Herman married in 1918 and bore 11 children. A graduate of the University of Pittsburgh Medical School, Charles was a traditional, small-town physician devoted to his patients. He routinely made late-night house calls and accepted food staples and miscellaneous household goods as remittance for his compassionate medical care.

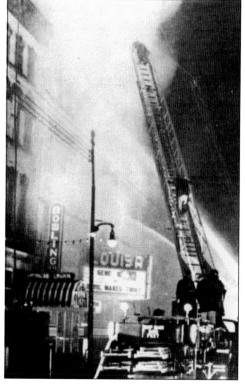

Charles owned several businesses in Carnegie, including four theaters: the New Carnegie (later the Louisa), the Grand, the Liberty, and the Dixie. After his death in 1948, the family, with William Fox, continued in the theater business, even participating in the operation of the Greentree Drive-In.

Born in Chartiers in 1883, James H. Duff, affectionately known as "Big Red," was elected governor of Pennsylvania in 1947. The tall, red-haired Republican completed a six-year Senate term beginning in 1950. He was felled by a fatal heart attack on December 20, 1969, and is buried in Chartiers Cemetery. The Governor's House apartment building now stands on Washington Avenue and Capital, the former location of Governor Duff's family residence.

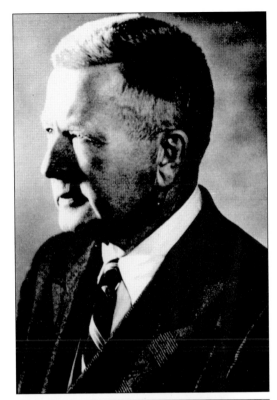

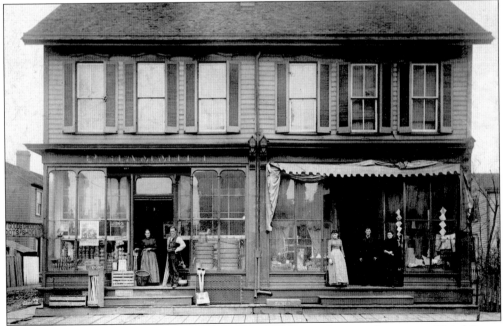

Catherine and Patrick Hammill stand in front of their residence and grocer at Third Street in pre-Carnegie Mansfield Borough, around 1890. Patrick was a devoted Catholic and was instrumental in the early organization of St. Luke's parish. The Hammill store was located across the street from St. Luke and thrived for many decades.

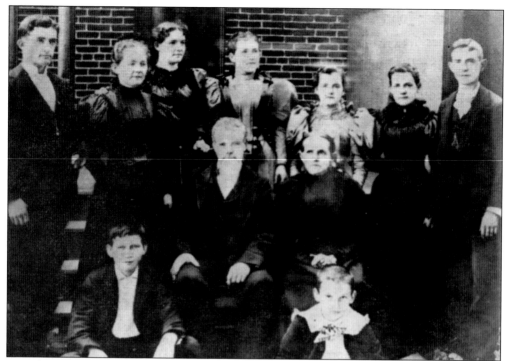

Patrick Hammill served on the First Church Committee of St. Luke parish. Here the patriarch poses with wife Catherine and their children Joseph, Patrick, Harry, Bert, Jane, Anne, Catherine, Chloe, and Bridget, around 1895.

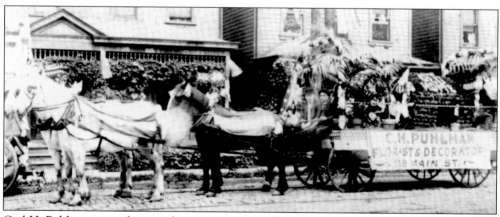

Carl H. Puhlman owned a greenhouse in Mount Lebanon and opened his floral design shop in Carnegie in 1908. The Puhlman Flower Shoppe was represented at Old Home Week that same year. The botanical business has been run by various members of the family and has moved to several different locations. But loyal customers know Puhlman Flowers as a Carnegie tradition for an astounding 98 years.

Two

SEASONS OF SERVICE

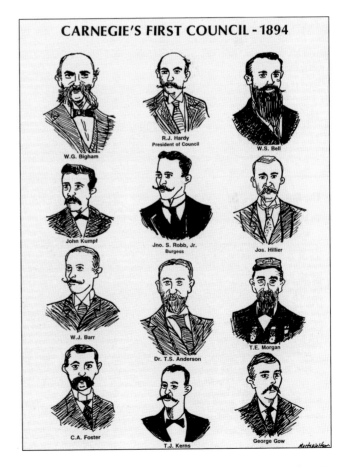

The first burgess of Carnegie was decided with a coin toss on February 21, 1894. Depicted in this drawing is Burgess John S. Robb Jr. and members of Carnegie's First Council.

21

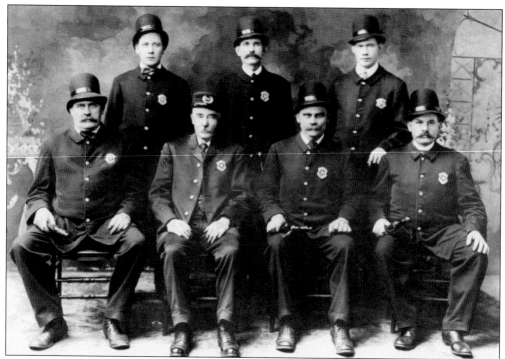

The Carnegie Police force maintained law and order in the early 1900s. Pictured in this photograph from 1908 are (first row) William Rosser, Chief Jacob Streitenberger, A. A. Tarter, and John Schuler; (second row) Cass Moran, Sly Dempsey, and George E. Reed.

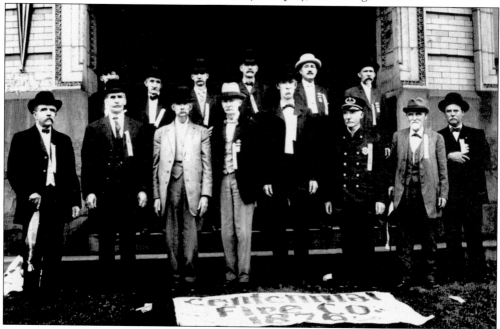

The Centennial Fire Company of Carnegie posed for this 1908 photograph. Indetified here are J. Kumpf, M. Carnahan, T. Kearns, G. Bigham, B. McDermott, F. Reno, S. Martin, W. Douglass, P. McDermott, F. Frederick, S. Bell, J. Streitenburger, Dr. R. Walker, and H. Lee.

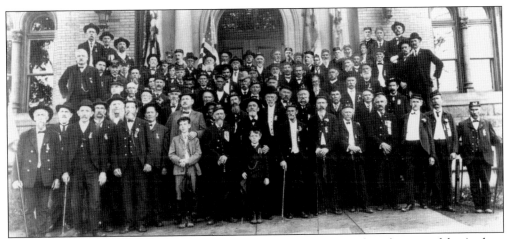

Civil War veterans from the Mansfield and Chartiers regions convened on the steps of the Andrew Carnegie Free Library for a 1904 group photograph. Under the Grand Army of the Republic (GAR), the group became the Captain Thomas Espy Post No. 153 and represented Carnegie. Later, veterans from Heidelberg, Rosslyn Farms, Crafton, and other neighboring communities joined the post, which dissolved in the 1930s upon the death of its last surviving member.

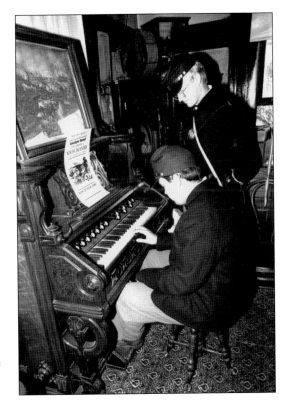

For more than a century, the Andrew Carnegie Free Library has housed memorabilia from the Civil War veterans who made up the Thomas Espy Post. Here Pvt. John Puskar and Pvt. Chris Sedlak try the organ in the Civil War Room.

23

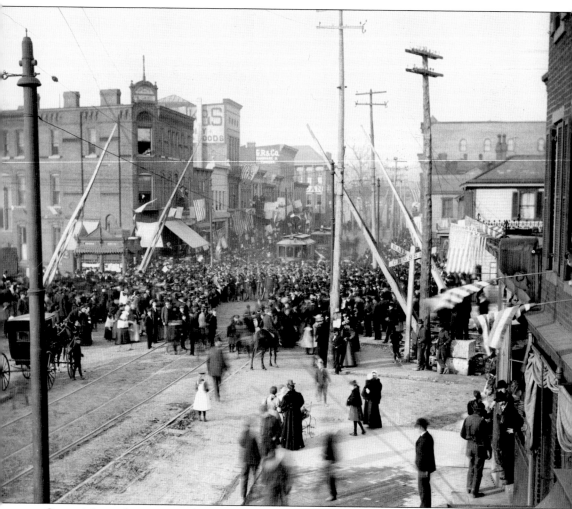

Carnegie's involvement in the war with Spain was limited. But in April 1898, Company K was organized as part of the 14th Pennsylvania Regiment. Sixty-three Carnegie men formed the National Pennsylvania Guard Volunteer Unit, and 7,000 of Carnegie's population of 7,300 showed up at a parade to send them off to battle. Pres. William McKinley signed a treaty officially ending the Spanish-American War on February 10, 1899. The soldiers of Company K, having spent their 10 months of service near Summerville, South Carolina, returned home to a hero's welcome on March 3. A parade and banquet were held in their honor one week later.

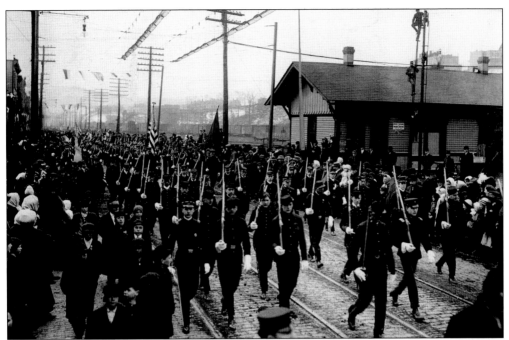

Veterans from the Civil and Spanish-American Wars march on Carnegie in the 1911 St. Patrick's Day parade.

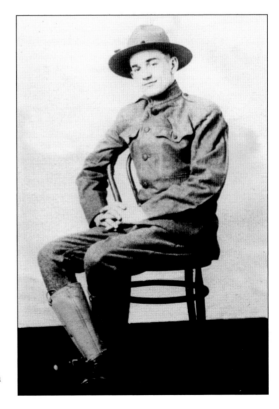

The first Carnegie casualty of World War I was August Klinkner. He was in the first group of volunteers and was killed in action on June 12, 1918, in France.

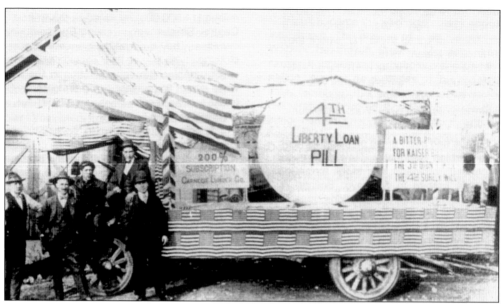

World War I was financed by a combination of taxes and bonds in the five huge Liberty Loan campaigns. In November 1917, Carnegie pledged nearly $600,000 in Liberty Bonds, an average of $53 for every man, woman, and child in the borough.

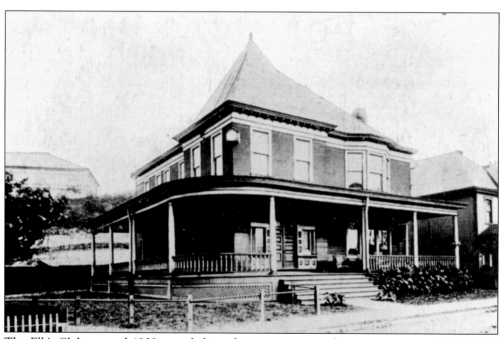

The Elk's Club, around 1909, was dedicated to various acts of community service and was a popular meeting place for generations of Carnegie men like Honus Wagner. He regaled his friends at the club with his colorful stories and tall tales.

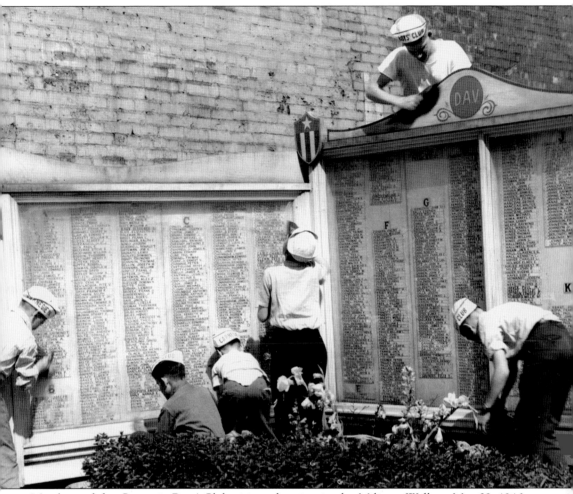

Members of the Carnegie Boys' Club visit and maintain the Military Wall on May 29, 1946. Pictured are Herman Bohnke (top), Charles Cooley, Robert Humler, Charles Knepper, Melvin Bryan, and Pete Parisi.

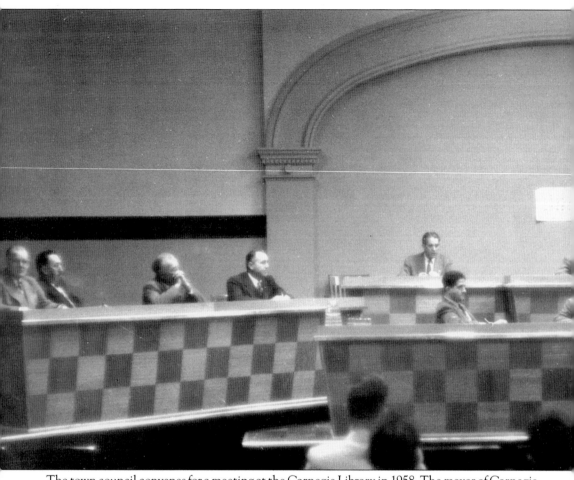

The town council convenes for a meeting at the Carnegie Library in 1958. The mayor of Carnegie,

Tele Coyne, officiated at the proceedings, which addressed community affairs and concerns.

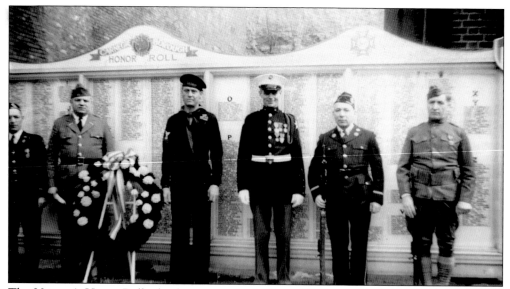

The Veteran's Honor Roll, also known as the Military Wall, stood before the post office and listed the names of 1,600 proud Carnegie veterans who served their country. It was built in 1944 and was dismantled during the late 1960s. A reconstructed honor roll adorns the front window of the Historical Society of Carnegie, located in the Husler Building.

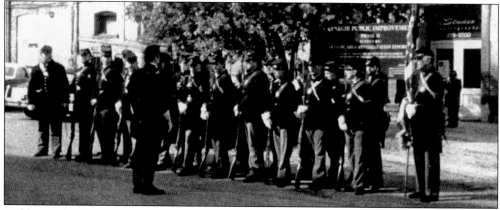

Led by Michael Kraus, actors reenact the Civil War in the Memorial Day parade in 1984. The event was part of a campaign to save the library's Civil War Room and included period music and a roasted ox. The room is now used by the Ninth Pennsylvania Reserves.

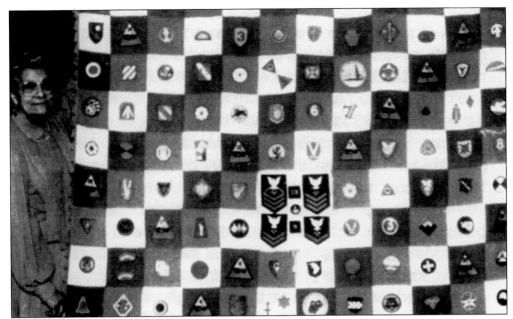

Ann Miraglia poses with the Military Patch Quilt she created with her brother, Bennie Magliocca, more than half a century ago. The quilt is comprised of 144 individual military arm-band patches hand sewn onto a blue taffeta backdrop. Following World War II, the quilt was displayed in the window of Gimbel's Department Store in downtown Pittsburgh but now is enjoyed as a private family heirloom.

The Carnegie Civic Club was formed in 1930 and existed until the late 1990s. The members have provided years of dedicated service to the community with numerous projects, such as purchasing street signs for the borough, supplying a Braille machine for the blind, and assisting other organizations like the Red Cross, Salvation Army, and Meals on Wheels. The group also awarded an annual scholarship to a deserving high school senior.

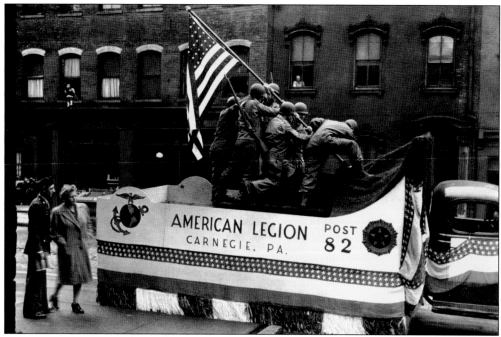

The American Legion Post 82 reenacts the famous Iwo Jima flag-raising at a Carnegie parade around 1948. The original photograph of the Iwo Jima soldiers was snapped by Joe Rosenthal and is said to be the most reproduced photograph in history.

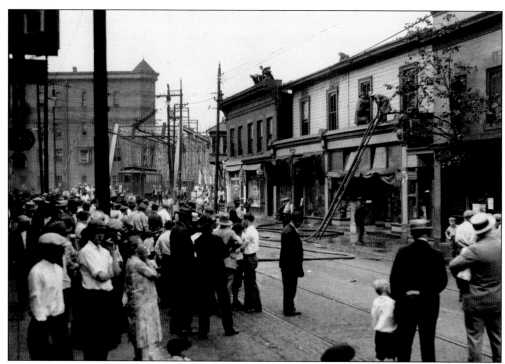

The fire company extinguishes a blaze on Main Street as onlookers watch from the street and nearby rooftops, around 1933. As depicted here, construction of the new bridge was underway.

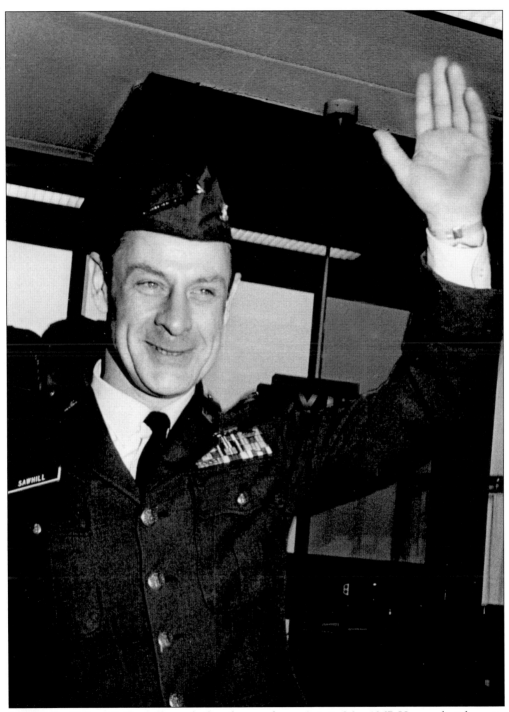

USAF pilot Robert R. Sawhill was deployed to southeast Asia in May 1967. He was shot down in his F-4 fighter plane near Hanoi three months later. He credits his strong faith with sustaining him for the five and a half years he was a POW. Hundreds turned out to welcome Sawhill home at a parade in his honor in April 1973. The Carnegie hero retired as a USAF colonel in 1996. He and his wife, Roni, moved to South Carolina.

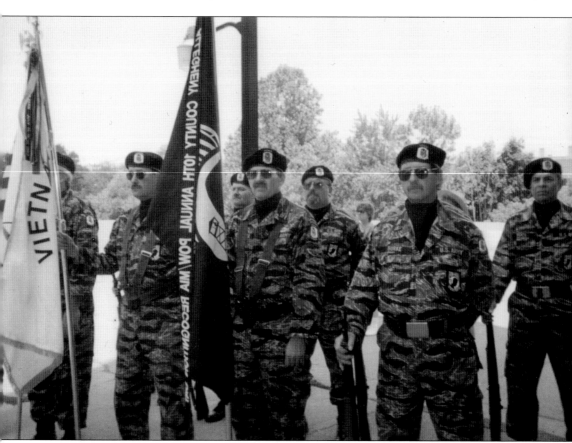

Veterans who served in the Vietnam War assemble in Carnegie Park for the Allegheny County 10th Annual POW/MIA Recognition Ceremony.

Three

WORSHIP

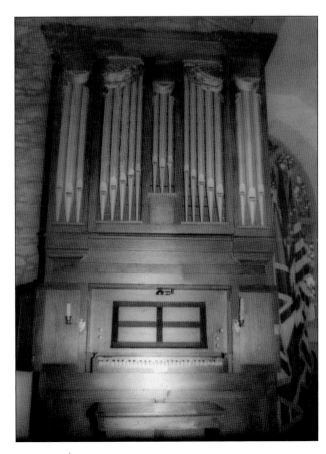

The oldest pipe organ west of the Allegheny Mountains was brought by Rev. Theodore Lyman from the former Trinity Episcopal Church of Pittsburgh to Old St. Luke in 1854.

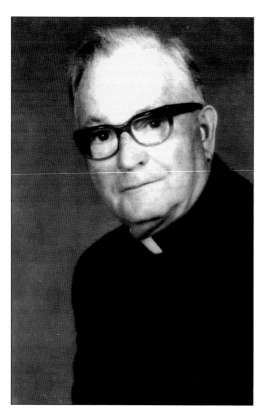

Rev. James F. Olko served as pastor of Immaculate Conception parish from 1945 until his retirement in 1983. Father Olko led his congregation through a multitude of changes and challenges, including the frequent flooding of Chartiers Creek and the building of a new church and school in the 1960s.

Once known as St. Mary's Polish Church, the Immaculate Conception Church was founded in 1893 under Fr. Francis Makowski. The parish served the large number of Polish families who emigrated from Europe in the 1870s. All of the church drawings included in this chapter were rendered by the Reverend Jim Garvey from Immaculate Conception parish.

The oldest church in the Carnegie area was the original St. Luke, known as Old St. Luke's. Erected in 1765, the Episcopal church was built in Woodville by Maj. William Lea, an English Army officer.

Descended from Old St. Luke's was the Church of the Atonement. The Episcopal church on Washington Avenue was eventually sold to the Salvation Army.

The latter St. Luke, a Catholic church, was established in 1867 and was both a "territorial church" and an Irish parish. St. Luke, St. Joseph, St. Ignatius, Holy Souls, and Immaculate Conception now comprise the St. Elizabeth Ann Seton parish. Masses are celebrated at Seton Hall on Mary Street and St. Ignatius on Finley. The flood of September 2004 badly damaged St. Luke and Holy Souls worship sites.

The Salvation Army began operating in Carnegie in 1932 under Capt. Lily Green. The organization later purchased the Episcopal Church and served Carnegie in that building until 1966. The Salvation Army has always been devoted to helping the poor and has been called upon many times to aid residents displaced by flood or fire. A humorous early motto of the Salvation Army was "soup, soap and salvation."

St. Paul's A.M.E. Zion Church was founded in 1866 in Mansfield by Amanda Adams. With husband Andy Workman, she rented a small house on Lydia Street where the church became organized. A new church building was erected on what is now Mansfield Boulevard in April 1868.

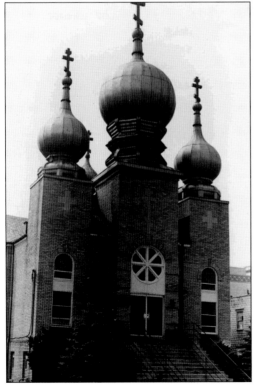

Holy Virgin Russian Orthodox Church was first established under Rev. P. Koch in 1909. Two houses were purchased to serve as a church and rectory with the addition of a Greentree cemetery in 1913. Holy Virgin served as the place of worship for Carnegie's Russian immigrants following their homeland's 1917 revolution. The present church building dates from 1920 and boasts an auditorium and banquet hall.

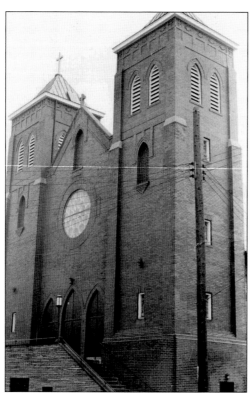

All Saints Polish National Church, as it was named in 1933, can be traced back to World War I where it was founded as the Holy Family Polish National Catholic Church. The parishioners had come together from other local churches in an effort to worship as they pleased in a "democratic" parish.

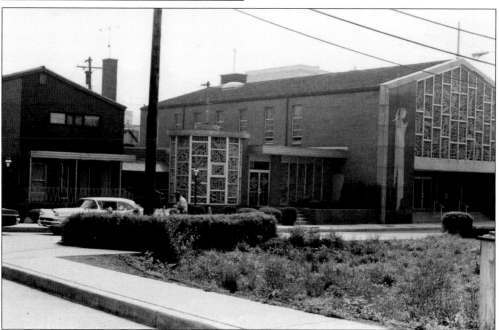

Holy Souls celebrated its first mass on Christmas Day in 1921, fittingly in a remodeled stable on Mary Street. A new church was built in 1923. During the Depression era, Rev. Ercole Dominicis established a soup kitchen to feed Carnegie's hungry. The beloved pastor celebrated his 50th Sacerdotal Jubilee in 1956. He passed away three years later.

Fr. Ercole Dominicis, founder of the Church of the Holy Souls, was born in Italy in March 1880. Here, Father Dominics administers the Apostolic Blessing in 1956.

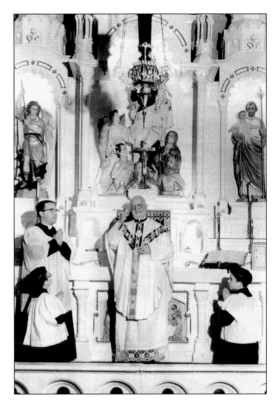

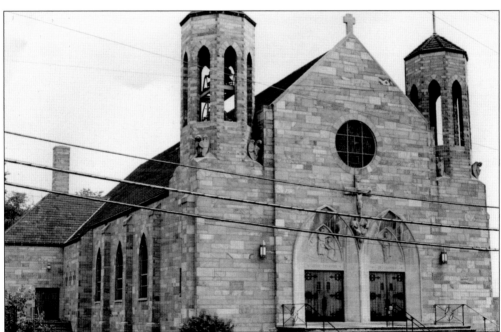

St. Ignatius of Loyola was built by Carnegie's faithful on Finley Avenue during 1902 and 1903. All construction help was volunteered by the parishioners, and no outside laborers were needed. The first pastor of St. Ignatius was Fr. Andrew Dziatkowski.

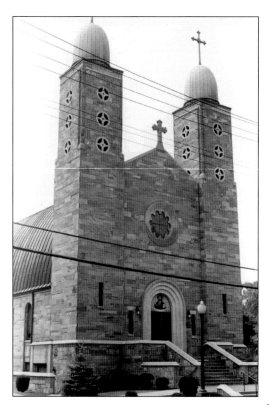

Holy Trinity Ukranian Catholic Church was officially blessed on November 25, 1954. The parish added a cemetery and then a rectory in 1960. The neighboring Steinmetz property was purchased for the church in 1967.

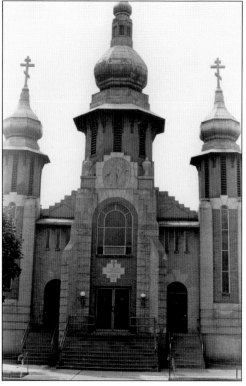

St. Peter and St. Paul Ukranian Orthodox Greek Catholic parish worshipped for a brief period at 220 Jane Street in Carnegie around 1901. Parcels of land were added, and the church was dedicated in July 1908. Fr. Theofan Obushkewich was the first parish priest.

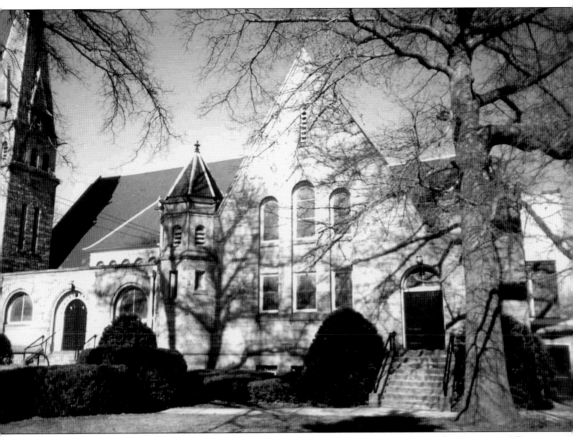

The First Presbyterian Church was organized by Mansfield Brown and his wife, Jane, in 1853. Originally the First Church Home, records reflect that it became the First Presbyterian Church of Carnegie on June 3, 1907. A school wing was added in 1915.

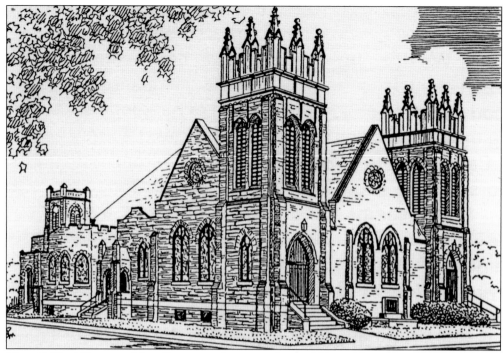

The old Wool House on Main Street was the original site of Christ United Presbyterian Church in 1856. The congregation was comprised of just three dozen members when it became known as the Mansfield Associate Reformed Presbyterian Church one year later. Following two fires, a new church was dedicated at the corner of Washington and Robert Avenues in 1889.

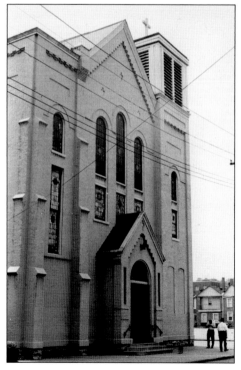

Like many of the churches in Carnegie, St. Joseph Roman Catholic was known as an ethnic parish. In 1879, the German Catholics in the Mansfield Valley realized a need for a German Catholic church. The founding parish comprised 75 families, and its first pastor was Rev. John Stillerich.

Beginning in 1967, the Reverend Sylvester J. Kress was the beloved pastor of St. Joseph parish. Kress was renowned for his efficiency and thrift of language during his traditional Roman Catholic services, which might best be described as "succinct."

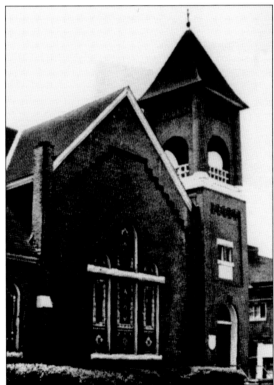

The First Regular Baptist Church of Mansfield Valley, later the First Baptist Church of Carnegie, was built at Washington Avenue and Academy Street in 1869. In 1894, the parish received a pipe organ as a gift from Andrew Carnegie.

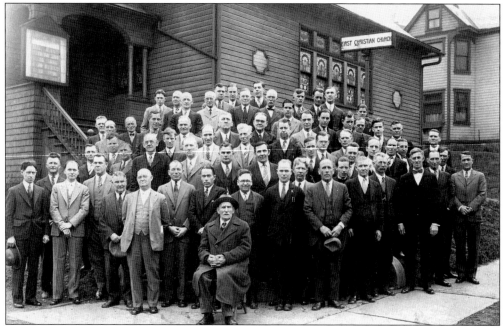

The First Christian Church of Carnegie sustained a devastating fire during a church meeting in the spring of 1894. The congregation was provided a place to worship by the First Baptist group while First Christian was being organized in the former Presbyterian building at East Main and Hays Streets.

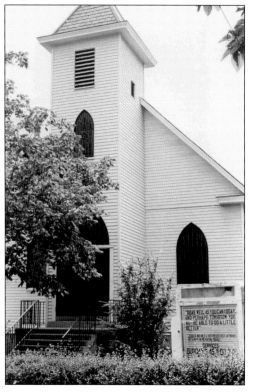

The First Primitive Methodist Church was organized on Fountain Street by Jabez Cooper Sr., James Bell Sr., and other founding families of Carnegie. A new church was dedicated in 1906 on Dow Avenue. A parsonage and school were added in the mid-1900s.

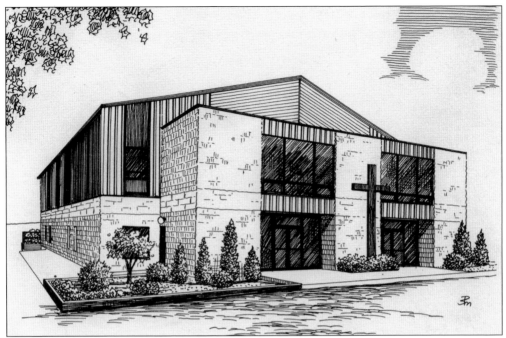

Carnegie's Full Gospel Church began in the early 1960s with cottage prayer meetings held in the Masonic building. Led by Rev. David R. Morgan, Full Gospel, now called Hillside Christian Community, moved to Campbells Run in 1981.

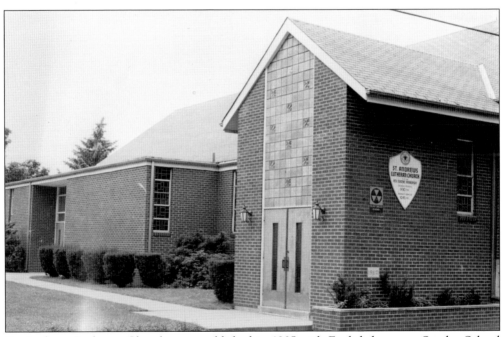

St. Andrews Lutheran Church was established in 1905 with English language Sunday School and worship services for Carnegie's German Lutherans.

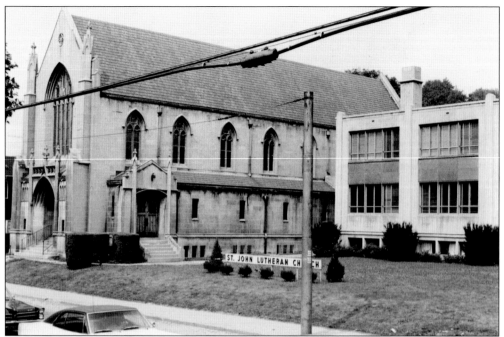

By contrast, St. John Evangelical Lutheran's services were conducted in German until 1925, and the meeting minutes were written in the German language until 1917. As an organization, St. John Evangelical Lutheran Church dates from 1872.

The Second Baptist Church began in 1888 with James Redd, Edward Greene, Joseph Lewis, James Lee, Thomas West, Edward Burleigh, and Rev. John Robinson as charter members.

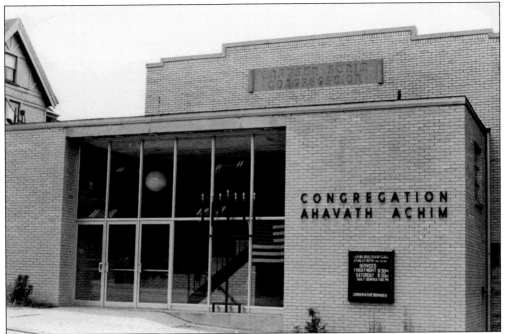

Located at Chestnut and Lydia Streets, Congregation Ahavath Achim, meaning "brotherly love," celebrated holidays in Husler Hall in the late 1800s. The Orthodox Jewish church was incorporated in 1903 as a place of worship.

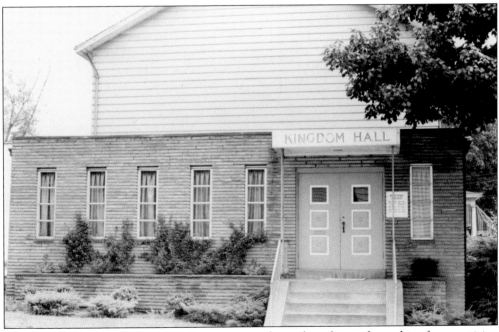

Kingdom Hall, on Washington Avenue, served as the place of worship for practicing Jehovah's Witnesses.

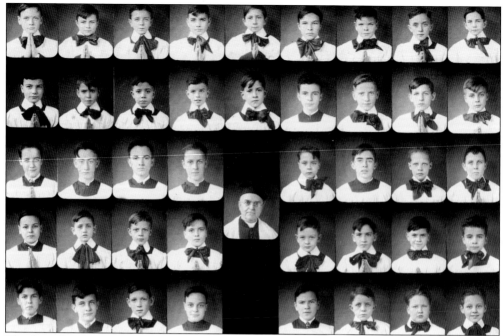

The St. Luke altar boys assemble for a group photograph in 1932.

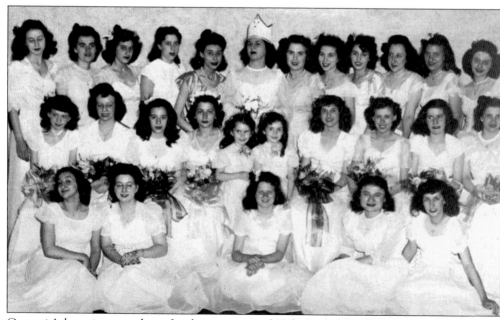

Carnegie's beauties turned out for the crowning of Holy Souls May Queen, Angeline Adamo, in May 1947.

Four

SCHOOL DAYS

The first official schoolhouse in the Carnegie area was located on the Forsythe property.

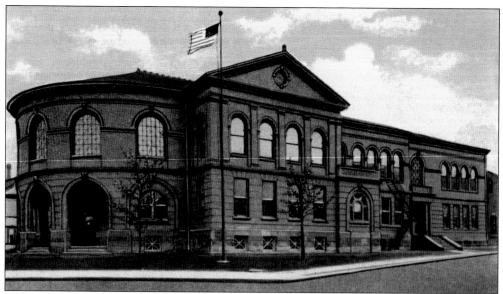

Carnegie's first high school opened in the fall of 1896 in the Women's Christian Temperance Union (WCTU) building, later the site of the Elk's Club. A building specifically designed to serve as Carnegie High School was later constructed in 1899. At that time, the high school curriculum was a three-year program. It was expanded to four years in 1914.

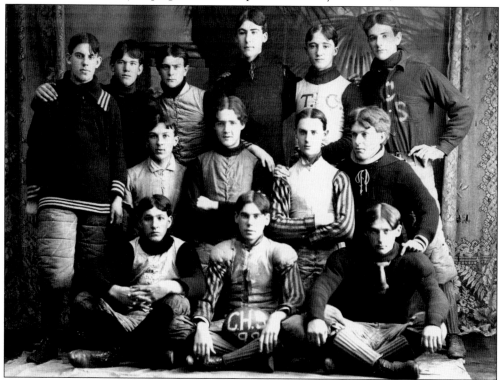

The first football team of Old Carnegie High School assembled for this 1899 photograph. The grand school building was founded that same year and served as the first of several structures used as a high school. The school closed in 1956.

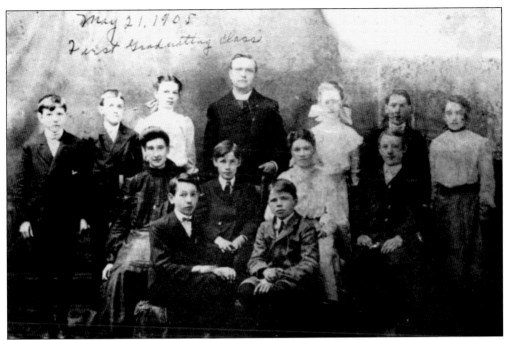

The first graduating class of St. Luke grade school celebrated in 1905. From left to right are (first row) John Mountain and Thomas Minahan; (second row) Marie Rattingan, Edward Connell, Marie Murray, and J. Leo Hayes; (third row) Peter McGarry, Edward McDonough, Margaret Gibbons, Rev. J. J. Brennan, Mary Hammill, James Mountain, and Agnes Connell.

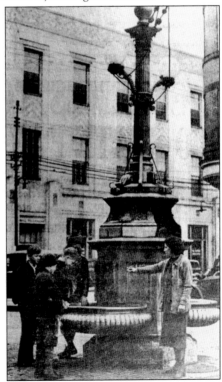

The WCTU fountain, depicted in 1934, was a popular meeting place in Carnegie. Built in the late 1800s to water horses, the fountain was later used to dunk high school freshman in an initiation ceremony.

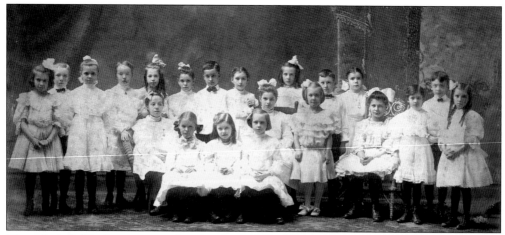

The Musical Kindergarten, under the direction of Miss Logan, assembled for this group photograph in 1904.

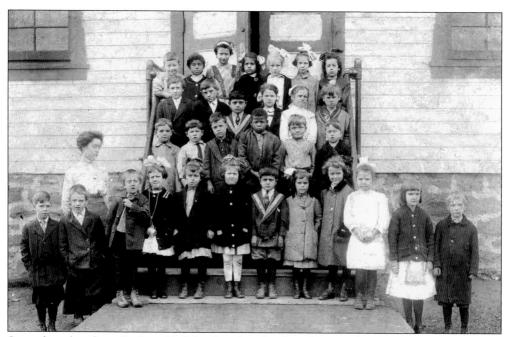

Second graders from St. Joseph's School gather for this photograph taken in the early 1900s. Carnegie pupil Alice White stands in the third row, fourth from left.

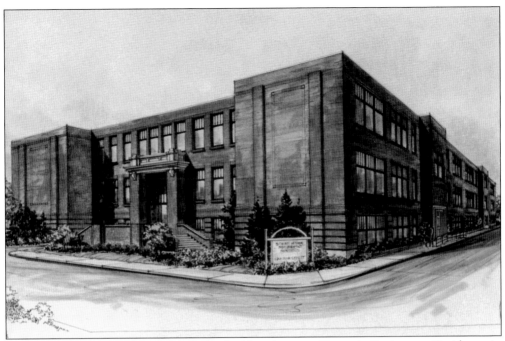

The former site of Harding School, this building became Carnegie Retirement Residence in the mid-1990s.

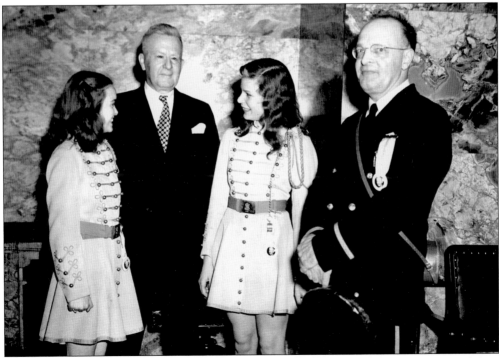

Gov. James Duff poses with members of the Carnegie High School marching band. From left to right are Jean Smith, Duff, Dorothy Sandrus, and Walter Cameron, the band's director.

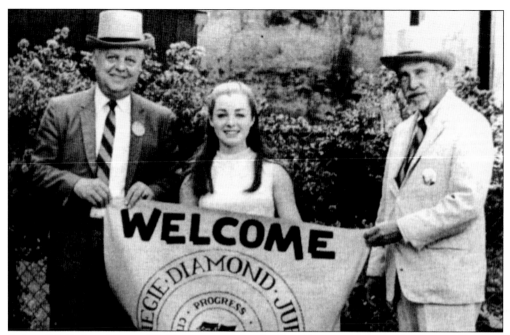

Robert W. Peel and James W. Knepper present the First Diamond Jubilee Banner to Charlene Langer around 1969. Langer, a senior at Carnegie High School, was declared the winner of the contest to design the official Carnegie Area Diamond Jubilee Celebration Seal. Judges were members of the town committee.

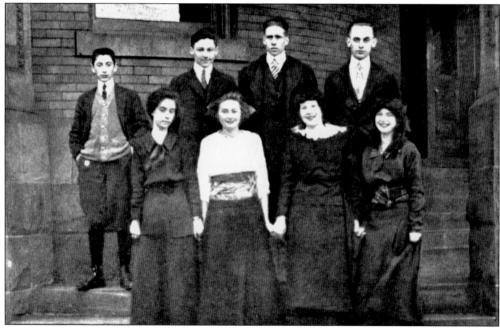

The yearbook staff from Carnegie High School posed for this 1915 snapshot. Their annual book was *The Censor*, and the president of the board and senior editor was William Love. From left to right are (first row) Virginia Hall, Marjorie Errett, Elizabeth Barr, and Margaret Walker; (second row). Michael Bachrach, William Errett, Gus Beard, and Love.

56

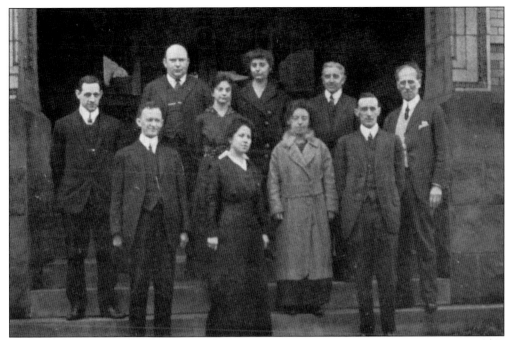

The Carnegie High School faculty around 1915 included Thomas J. George, Annie Campbell, Norman Glasser, Robert Doyle, Rosetta Morrison, David George, Frances Brown, John Loeber, O. H. Philips, Charlotte Clemens, and Ethel Canfield.

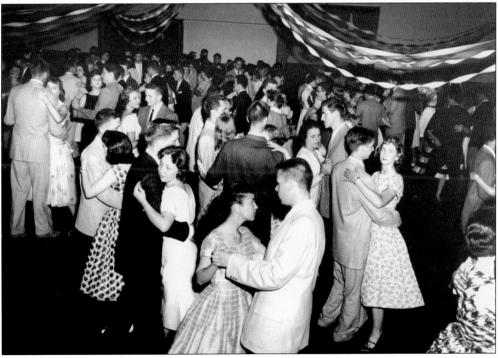

David Jewelers hosted an annual dance for high school seniors. Here in 1959, the fashionably dressed students enjoy the festivities held at Carnegie Danceland in the Masonic building.

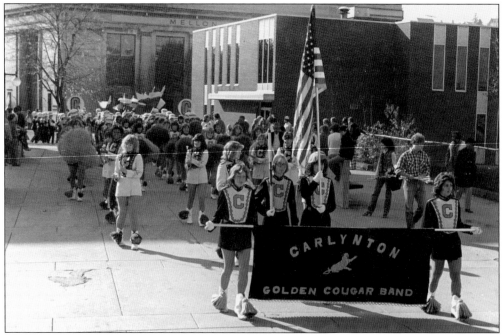

The Carlynton Golden Cougar band entertains the crowd at the annual Halloween promenade. Carlynton High School was founded in 1970 and united the communities of Carnegie, Crafton, and Rosslyn Farms.

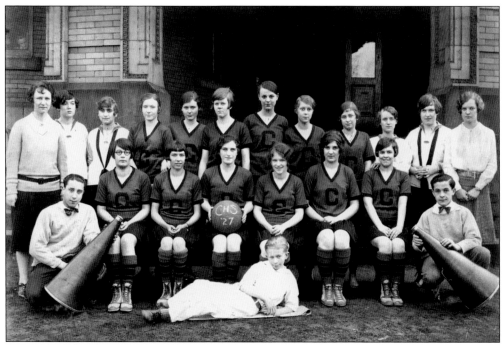

Carnegie High School was renowned for its academic curriculum, as well as its various clubs and athletic opportunities. Sarah Corbett coached the 1927 girls' basketball team for Carnegie High.

Many students in the Carnegie zip code attended classes in the Chartiers Valley School District. Char Val (CV) was formed in 1956 with the merger of schools in Bridgeville, Collier Township, Heidelberg, and Scott Township. In 1996, *Money* magazine named CV as one of the top 100 school districts in the nation based on several variables including academic excellence and Scholastic Aptitude Test scores.

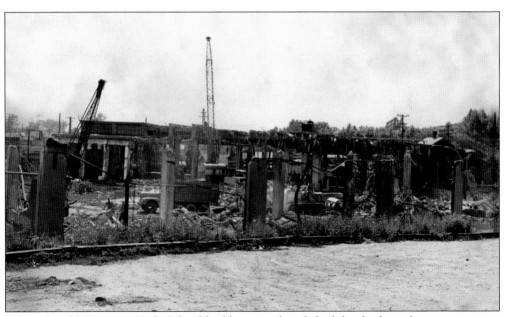

When the old Carnegie High School building was demolished, bricks from the structure were used in the construction of new homes on Cubbage Hill.

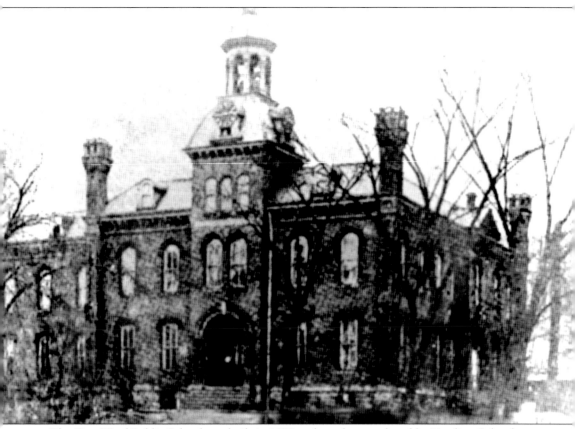

The First Ward Public School was built in 1878 and was later replaced by Harding School.

Five

LEISURE AND RECREATION

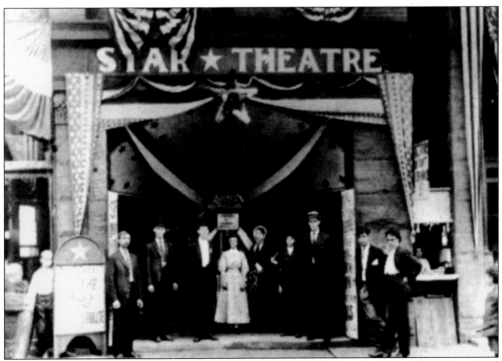

Carnegie residents flocked to the Star Theater, which opened its doors in 1906. Owned by William Jarvis, the Star was the first theater in town to show silent movies, among them Edwin Porter's *The Great Train Robbery*. A female vendor can be seen tucked alongside the Star selling soda pop.

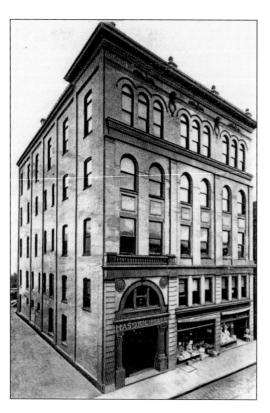

Carnegie Danceland was located on East Main Street in the former Masonic building. Performers like Mel Torme, Patti Page, and Tony Bennett visited Carnegie Danceland regularly during the 1950s.

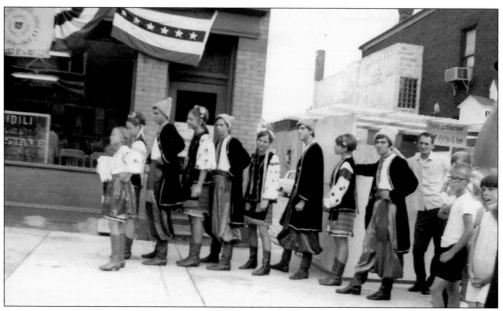

Ukranian dancers performed at the Carnegie Diamond Jubilee, which commemorated Carnegie's 75th anniversary on August 16, 1969.

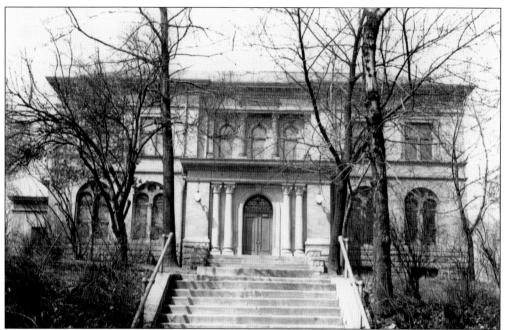

The Andrew Carnegie Free Library and Music Hall has been serving Carnegie as well as neighboring areas like Pittsburgh since 1901 and is the perfect venue for an afternoon's entertainment. The grand library boasts a reception hall and Civil War Museum and sponsors a variety of activities and educational programs each month.

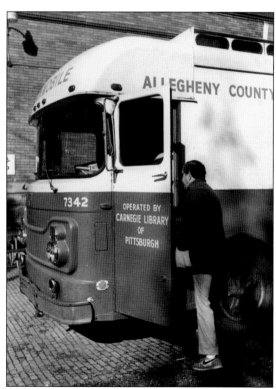

A visit to the Carnegie Library Bookmobile was always a special treat for area schoolchildren in the 1970s and 1980s.

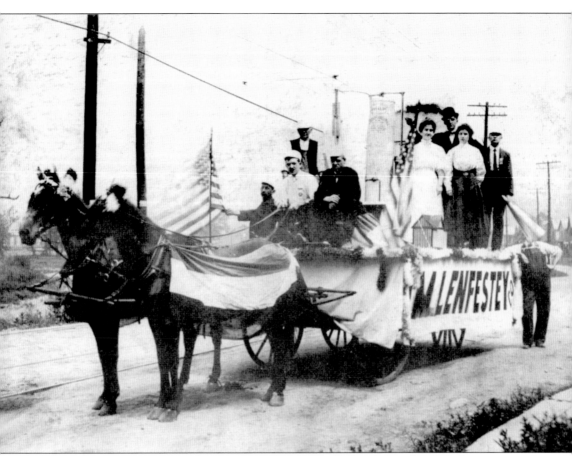

Lenfestey's Hardware showed off a patented hot-water heater during the 1910 Carnegie parade. The parades of the early part of the 20th century were grand affairs with many businesses decorating their carts and wagons to create elaborate floats.

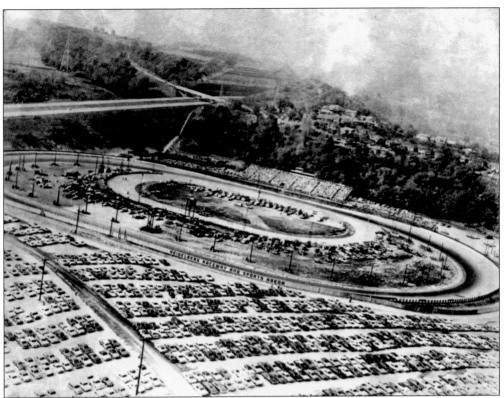

The Heidelberg Raceway opened in 1948 and was an early venue for racers like Lee Petty, father of Richard Petty, in the National Association of Stock Car Auto Racing (NASCAR). By the early 1960s, the half-mile track, originally made of dirt but paved in 1967, was hosting demolition derbies. In 1973, the track was torn down and replaced with a suburban shopping plaza.

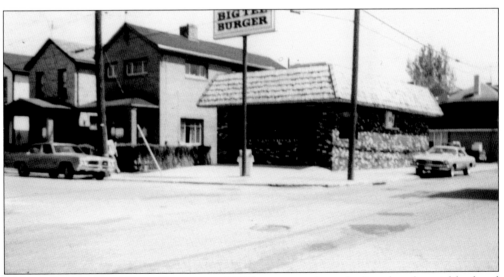

The Big Tee Burger and Tastee Freez, around 1976, was a popular gathering place for neighborhood teens and families for several decades. The restaurant was located across from St. Joseph Church at Second and Third Avenues.

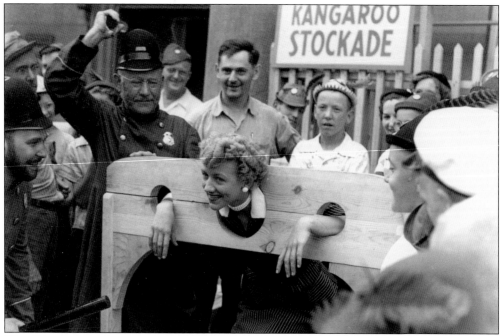

The Diamond Jubilee was a festive occasion commemorating Carnegie's 75th anniversary. Even this unlucky lady, condemned to the guillotine by this kangaroo court, is enjoying the celebration.

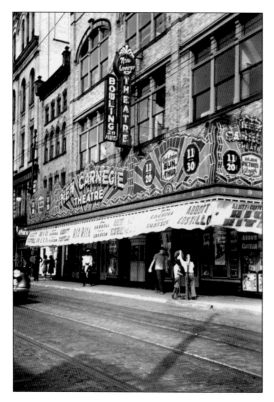

The New Carnegie Theater on Main Street, here featuring Abbott and Costello in the 1940s, was one of the four theaters owned by Dr. Charles Herman. The theater showed first-run movies and hosted vaudeville acts. And there were two floors of bowling lanes above.

Ushers John Musiol, Joe Loibel, and Clem Kleer from the New Carnegie, later named the Louisa, greeted and seated visitors in the 1930s and 1940s. The theater featured materials and mementos from various locales. Dr. Charles E. Herman's nephew Joe Herman brought the stones for the stage from out west.

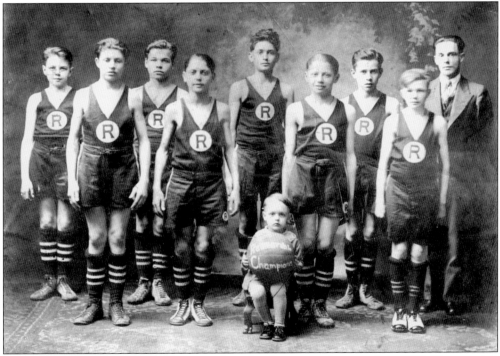

The Rennerdale boys' basketball team gathers for this group photograph in 1928. The cute kid in the center was a little short to dunk the ball, so he served as the team's mascot.

The Carnegie festival of 1992 offered fun for the whole family. In addition to refreshments and games, there was also a petting zoo for the children.

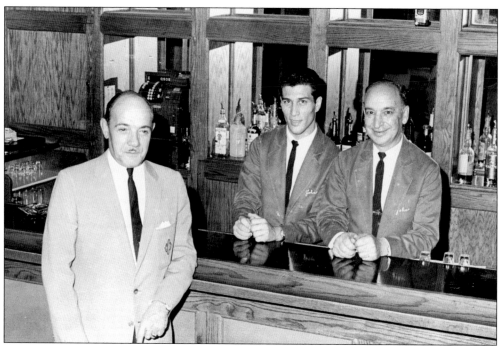

Members of the Chartiers Country Club, founded in 1924 as Chartiers Heights Country Club, enjoyed a round of golf on the beautiful 18-hole course, often followed by cocktails in the clubhouse. Pictured are two of the club's bartenders around 1960.

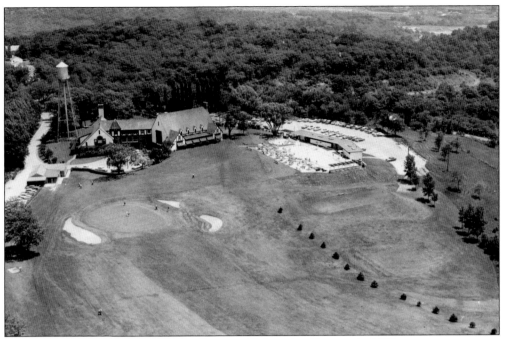

This aerial view shows the Chartiers Country Club and golf course in 1956.

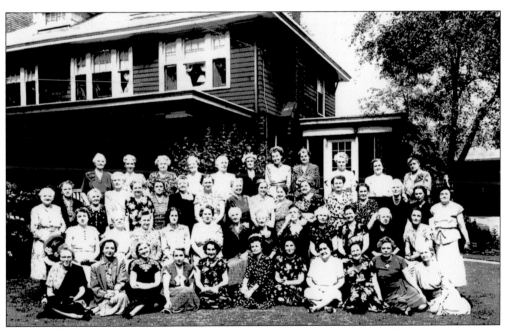

Members of the Monday Club gather for a group photograph around 1900. Members of the literary and social club enjoyed conversation and refreshments several times per month, with meetings held in the members' homes. The group also produced a yearbook containing book reviews and articles beginning in 1901.

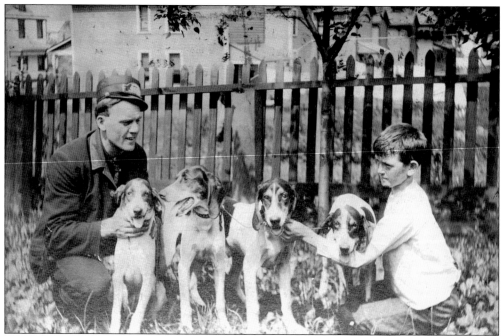

This gentleman and his young companion enjoy a warm afternoon in the company of man's best friend. The Davidson family dogs are poised for a long run or perhaps a duck hunt out in the field.

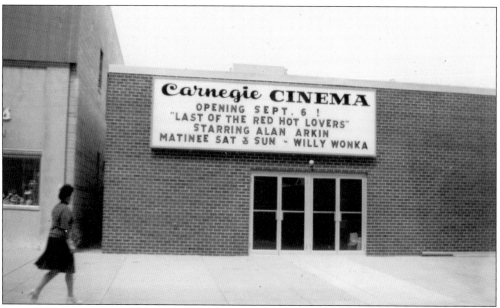

The new Carnegie Cinema on East Mall Plaza followed in the town's long-standing theater tradition. In 1972, the theater opened with Neil Simon's *Last of the Red Hot Lovers* and *Willy Wonka*. Like many of Pittsburgh's small, independent cinemas, the Carnegie was phased out by the large multiplexes that popped up during the 1980s and 1990s.

Six

TRANSPORTATION
AND INDUSTRY

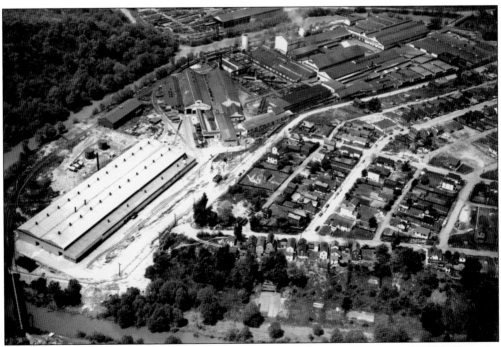

This aerial view represents Carnegie's Superior Steel Corporation around 1956. From its humble beginnings in 1893 until it closed more than 60 years later, the steel company employed generations of families. Superior's first order was for a single coil of cold rolled strip. By 1909, it boasted a large cold mill, three hot mills, four furnaces, an annealing house, a machine shop, and a boiler house. The plant closed on March 2, 1962.

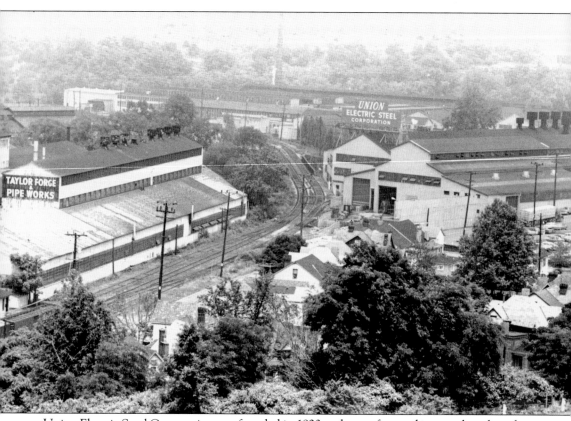

Union Electric Steel Corporation was founded in 1923 and manufactured iron and steel products like railroad axles, crankshafts, and piston rods. The company's skill in steel processing was called upon during World War II to manufacture gun barrels.

Carnegie Savings Bank originated in 1891. Initially called the German Building and Loan Association of Chartiers Borough, the organization was dedicated to aiding area residents in purchasing homes.

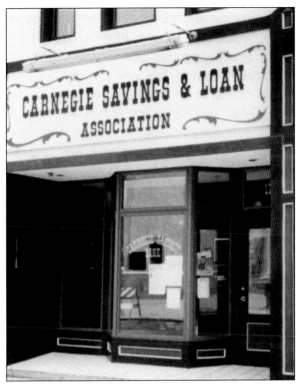

A hallmark in Carnegie for more than 75 years, the Henry R. Henney Funeral Home stands on Washington Avenue. The original structure was the birthplace of Henney patriarch H. G. Henney and was formerly located on Chestnut Street.

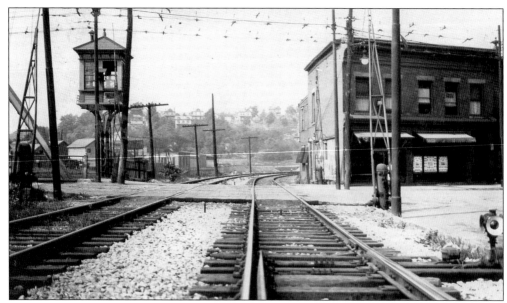

The watchman's tower is depicted at left in this photograph looking eastward from the Main Street tracks. The train tower was manned by an operator who manually controlled the safety bars at the busy crossings. The tower was razed in the 1970s, and the bridge is now part of the pedestrian mall.

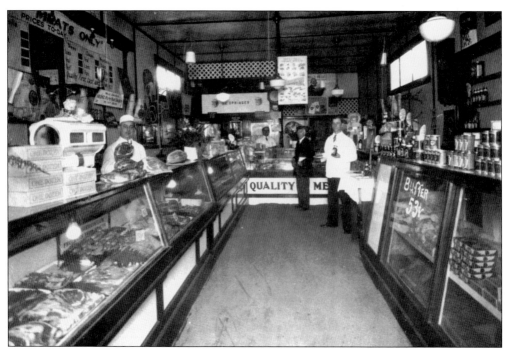

Butchers and a Carnegie shopper conduct their business at the W. E. Springer Market around 1928. In the 1920s, Carnegie was a community of specialty shops that catered to streetcar commuters. As was common for the era, the Springer Market boasted a sawdust-covered floor.

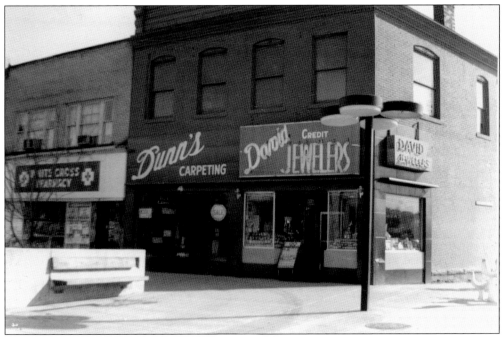

Specialty retailers like David Jewelers, Dunn's Carpeting, and White Cross Pharmacy thrived on the west end of East Mall Plaza around 1970.

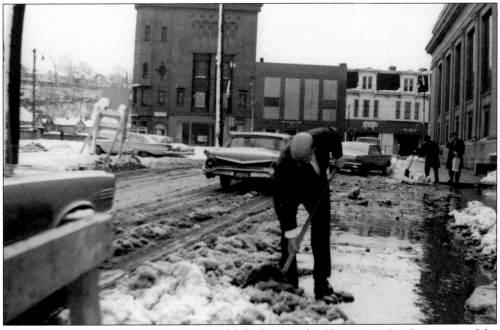

Bradwell and Nirella Funeral Home was established in 1869 by Christian D. Steel, a veteran of the Civil War. The business was originally located on First Street and then moved to Chartiers Street in 1932. Undertaker Joe Nirella shovels the snowy walk outside the funeral parlor in April 1967.

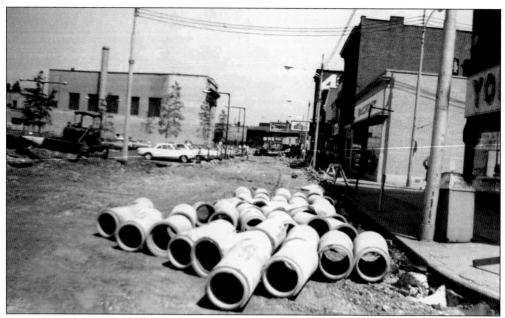

Carnegie's redevelopment process began in the spring of 1965. Depicted here is evidence of the ongoing construction on West Main Street around 1968. The redevelopment plan of the late 1960s involved the building of a second bridge; widening Jane Street to four lanes, later known as Mansfield Boulevard; and addressing the serious problem of flood management. This period also reflected a strong economy in Carnegie, and the retail businesses thrived.

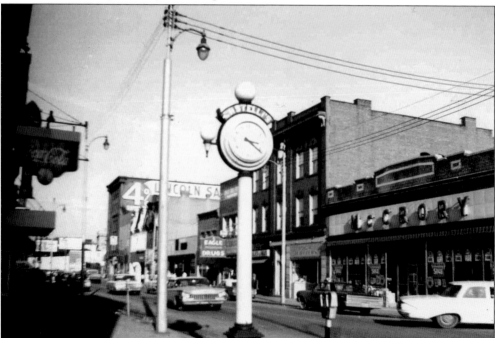

West Main Street in the mid-1960s was dotted with specialty shops and five-and-tens like McCrory. Castelli's clock, owned by Castelli Jewelers, was a famous landmark in Carnegie and the official marker of time for the community.

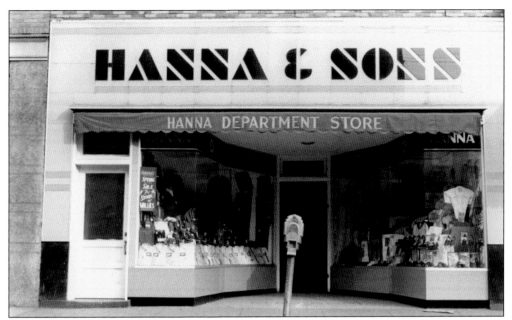

Hanna and Sons Department Store was established as a Carnegie business in 1903. Located on West Main Street, the store was originally owned by Philip Hanna. The area thrived at the beginning of the 20th century, with the Grand Theatre and a donut shop, just a few of the other nearby attractions for Hanna's shoppers. The Hanna family still operates a clothing store in the 300 block of West Main Street.

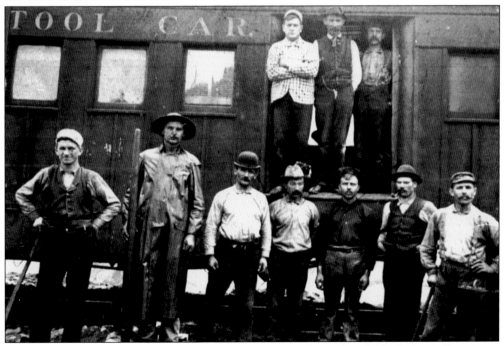

During the 1920s, the railroad companies retained an employee they dubbed "the Caller." It was the caller's job to visit the homes of railroad workers in the middle of the night to wake them in time for their shifts.

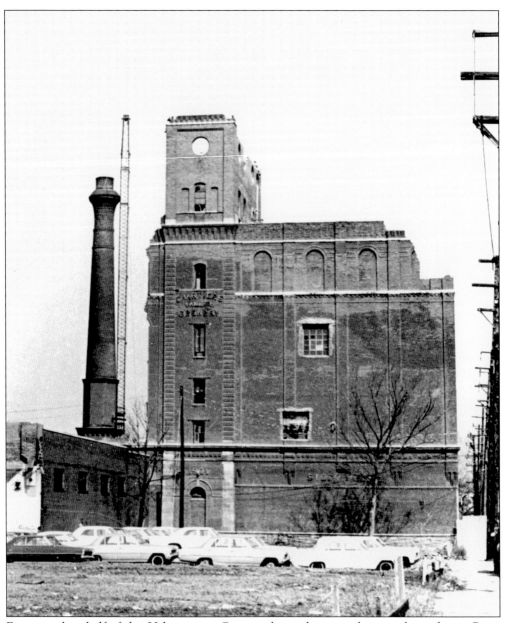

For more than half of the 20th century, Carnegie boasted its own brewery, located near Batey Chevrolet. Initially the brewhouse was called Chartiers Valley Brewery. The name was later changed to Carnegie Brewery, and its slogan was "What Carnegie Makes Makes Carnegie." Big-league competition forced its closing in the early 1950s, when it was known as the Duquesne Brewery. Duke Beer was the label of choice for discriminating Carnegie beer drinkers.

Known as "Jim," Vincent Falleroni operated a market at 608 Arch Street for 55 years. A trusted friend to many in the community, he issued credit to customers suffering financial hardship and offered use of his truck and telephone. Several members of the Falleroni family gathered for this 1928 snapshot.

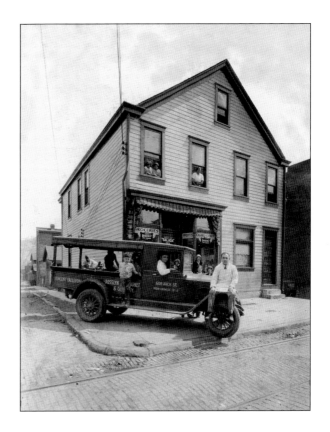

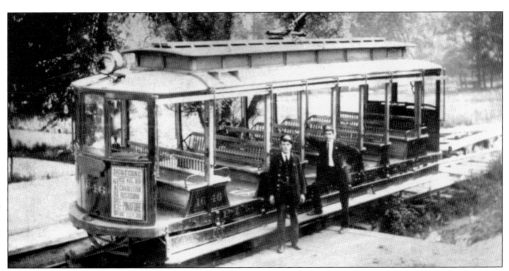

At the start of the 20th century, streetcars ran from downtown Pittsburgh through Crafton Heights and Carnegie, then made the turnaround at the Superior Steel loop. Pittsburgh Railways also ran streetcars from East Carnegie down Washington Avenue into Heidelberg. Many residents bypassed street traffic and opted to make the commute to Kennywood Amusement Park by train or trolley.

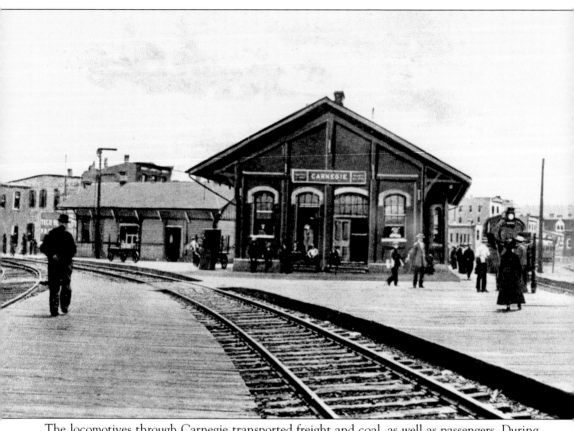

The locomotives through Carnegie transported freight and coal, as well as passengers. During the 1920s, a train passed through the town every seven minutes, and passenger trains stopped at the station close to 30 times per day. This photograph shows the Panhandle Station in Carnegie. Next to the passenger station is the freight station.

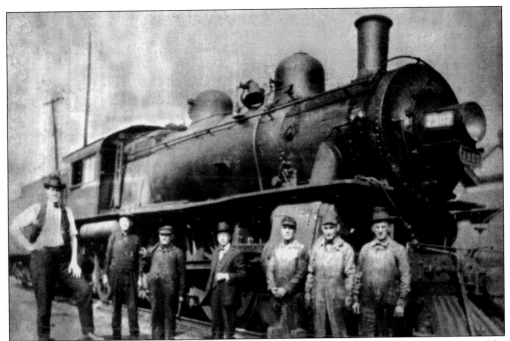

Workers from the Panhandle Railroad show off their locomotive around 1920. Bob Keenan (far left) was the clerk, and Billie Cole (third from left) was the foreman.

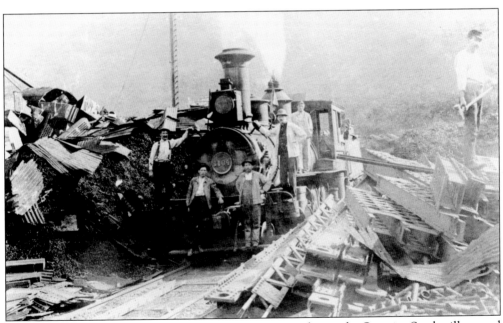

The train rides the rails through the Solomon Scrap yard near the Superior Steel mill around 1920. The turnaround loop for the railroad was located at Superior.

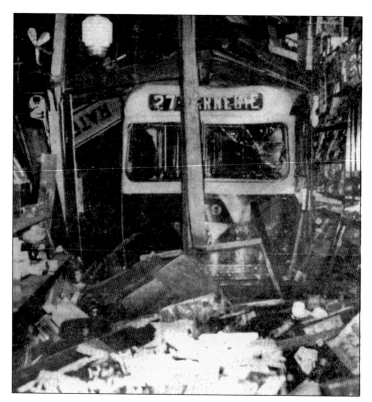

On April 22, 1941, a trolley jumped the streetcar tracks and crashed into the store at Third Avenue and West Main Street. Several people were injured in the wreck.

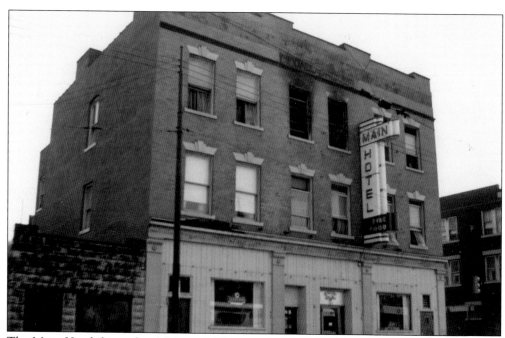

The Main Hotel, located at Main and Chestnut Streets, sustained a fire in March 1968. The building was restored, but closed its operation in the mid-1990s.

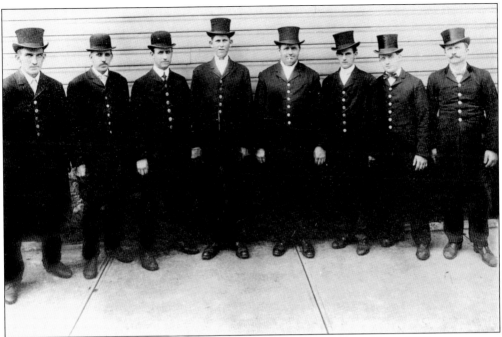

The carriage drivers for the McDermott Brothers Funeral Home assemble in 1900.

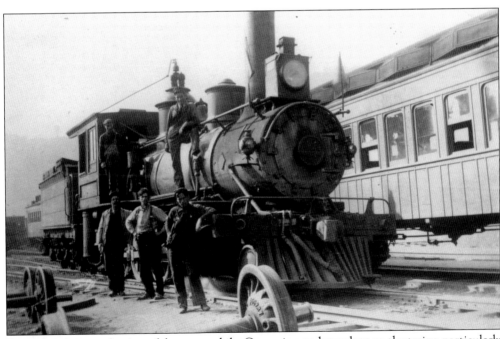

Even after the introduction of the automobile, Carnegie was dependent on the trains, particularly at the beginning of the 20th century. The town suffered greatly when a snowy winter gridlocked the railroad during the 1917 holiday season. Critically needed medical supplies were held up, and furloughed servicemen returning home to celebrate with loved ones became stranded.

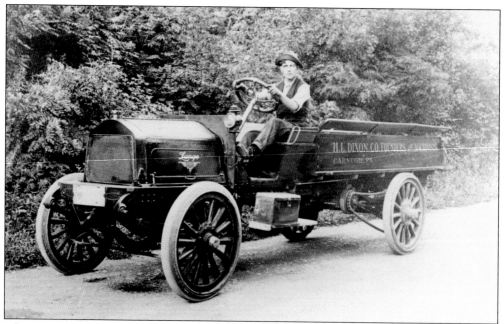

John E. Dauble drove this early model company truck for the H. L. Dixon Company around 1914. Note the vehicle's chain drive.

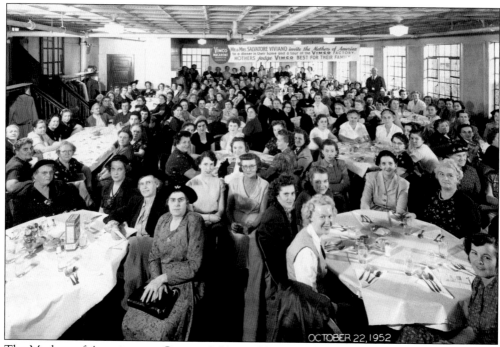

The Mothers of America tour Carnegie's Vimco Macaroni factory in October 1952. Of course, Vimco pasta was on the menu.

Seven

HOMETOWN HERO

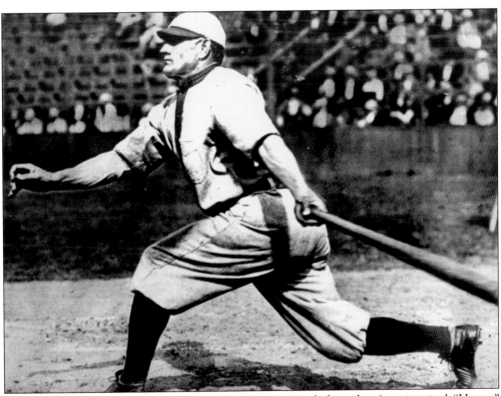

Johannes Peter Wagner was known by many names, including the Americanized "Honus," a variant of John. He was dubbed "Old Bowlegs" and the "Flying Dutchman" by the press. "Dutch" came from the German "Deutsch," as the Wagner family, like so many who settled in the Mansfield area of Pittsburgh in the late 1800s, immigrated from Bavaria in Southern Germany. Mansfield later merged with Chartiers Borough to become Carnegie.

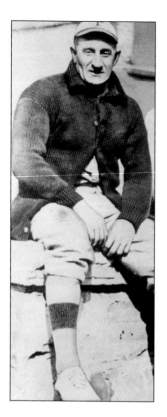

Honus Wagner was discovered by a baseball scout who happened upon the young man casually tossing rocks, with pointed power and accuracy, along a railroad track near Wagner's hometown of Carnegie.

After a brief tenure in the minor leagues, Wagner began his major-league career with the Louisville Colonels. He played in the first World Series in 1903, a nine-game battle between the Pittsburgh Pirates and the Boston Pilgrims. Six years later, Wagner celebrated his first World Series victory when the Pirates beat Detroit.

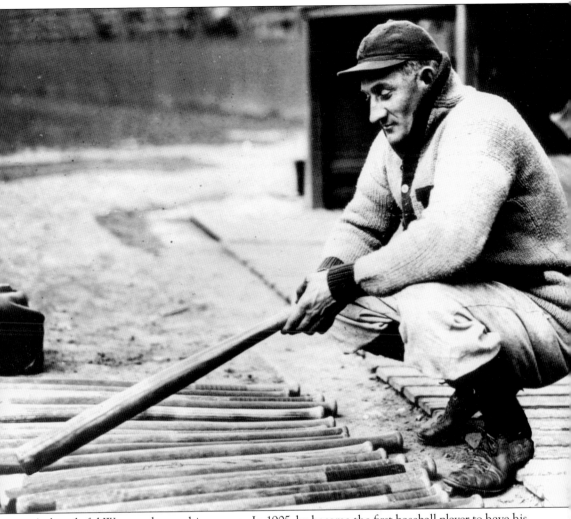

A thoughtful Wagner chooses his weapon. In 1905, he became the first baseball player to have his signature branded into a Louisville Slugger baseball bat. A modest man, Wagner did concede, "I could always slam the ball." Wagner proved it again in the 1909 World Series, hitting .339 for the Pirates against Detroit's Ty Cobb. The Pirates won the series with a score of 8-0 in the final game.

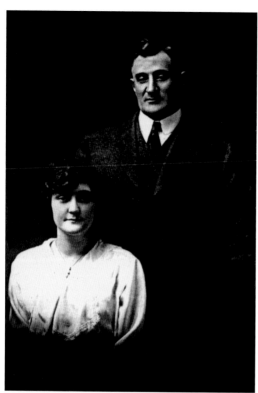

The marriage of Bessie Baine Smith and Honus Wagner made national news in 1916. The pair had enjoyed a lengthy courtship that culminated in a small, private ceremony at St. John's German Lutheran Church on Highland Avenue. The Wagners honeymooned in the southwest and returned to Carnegie to begin their married life together.

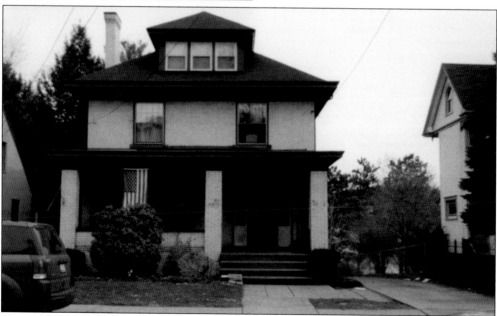

This solid brick residence on Beechwood Avenue served as the family home of Honus and Bessie Wagner throughout their married life. The pair wed when Wagner was 41. He joked that his new bride, Bessie Baine Smith of Pittsburgh, was an apt companion with "baseball in her genes," alluding to his father-in-law's "sweet curveball." At the time of this writing, plans were in the works to turn the Wagner home into a bed-and-breakfast inn.

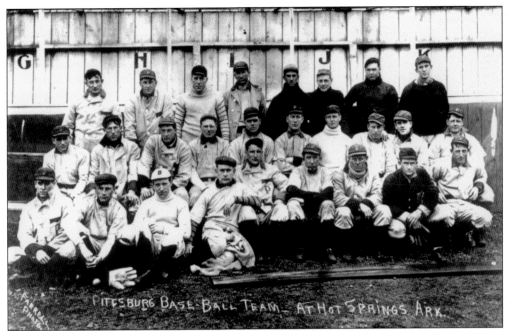

The 1913 Pirates team posed for this group photograph during spring training in Hot Springs, Arkansas. Wagner was hailed as an all-around player who excelled in all aspects of the game. The shortstop was 34 years old before he played one position for a full season, and his peers agreed that he would have achieved hall of fame status in any position he played.

Wagner was a member of St. John's German Lutheran Church. The primitive structure still stands on Highland Avenue, along with the tiny adjacent building that served as a schoolhouse. Wagner took advantage of all the schooling that was available to him at that time, joining his father and brothers in the coal mines when he was 12.

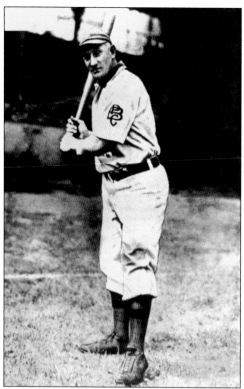

During Honus Wagner's playing career, baseball uniforms sported only the team and players' names. Numbers on jerseys became popular during Wagner's tenure as a Pirates coach. At that time, Wagner sported 33 on his uniform, a number that the Pirates retired in his honor.

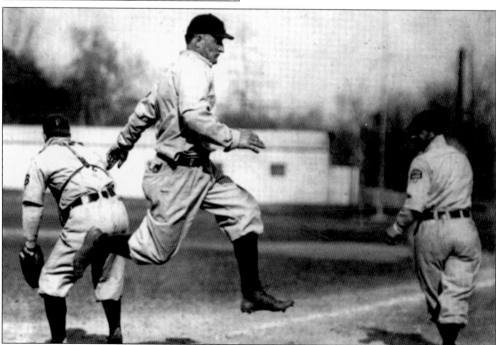

The Flying Dutchman goes airborne as he rounds the bases. Wagner led the National League in batting eight times and had a lifetime batting average of .329. He also led the league five times in stolen bases, with a career high of 61 stolen bases in 1907 alone.

Hall of famer Honus Wagner was a hero both on and off the baseball diamond. Wagner's T206 tobacco card, dubbed the "Mona Lisa of baseball cards," is the most prized by collectors, as it was recalled in 1909 at the insistence of Wagner himself. Although the shortstop was a cigar smoker, he objected to his card being distributed in tobacco products, which he believed would set a bad example for children. (Courtesy of the Historical Society of Carnegie.)

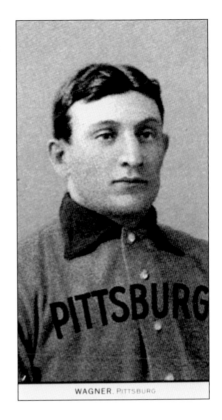

WAGNER, PITTSBURG

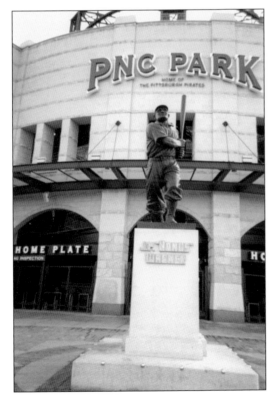

Sculptor Frank Vittor immortalized Wagner with this bronze statue in 1955. A weakened Wagner attended the parade and unveiling ceremony but returned to his Carnegie home before the event had concluded. The statue debuted at Forbes Field and then later moved to Three Rivers Stadium. When the Pirates built PNC Park, their hometown hero moved again. The Wagner statue now greets fans at the main gate.

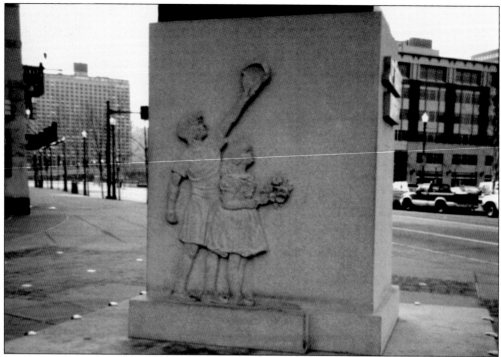

Honus and Bessie Wagner's granddaughter Leslie posed with her famous grandfather and is one of the children depicted at the base of Vittor's statue.

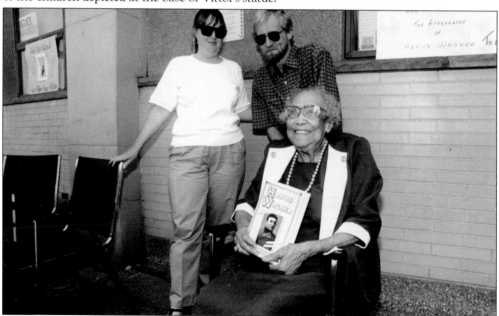

Wagner biographers Jeanne Burke DeValeria and Dennis DeValeria pose with the late Mabel Aston Thornhill, longtime housekeeper to Honus and Bessie Wagner. Mabel worked for the family from the time she was 18 years old. The good-natured housekeeper was routinely tipped by her famous employer's ballplayer friends who dropped in for dinner, which often included Limburger cheese and red cabbage, two of Wagner's favorite foods.

An aging Wagner displays his playful side as he digs into a plate of one of Mabel's home-cooked meals.

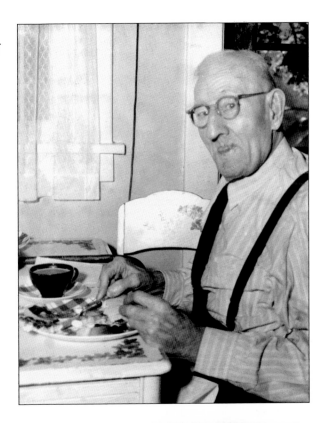

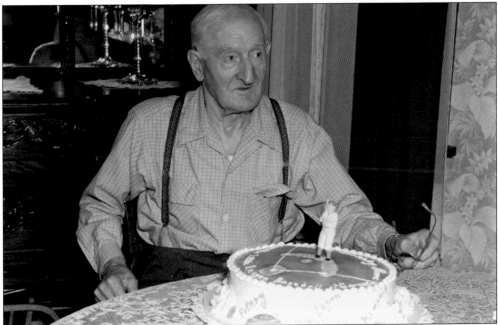

In February 1952, the Carnegie Little League presented Wagner with a cake to commemorate his 78th birthday, as well as his retirement from the Pittsburgh Pirates. Wagner had served the Pirates organization for more than half a century.

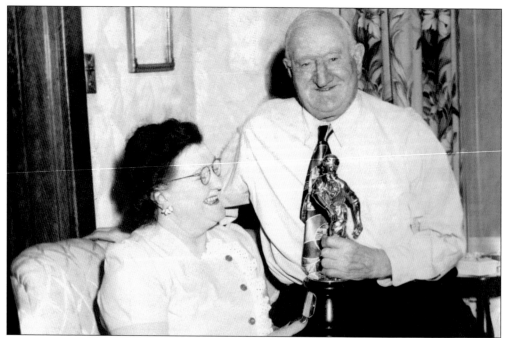

Bessie and Honus Wagner admire a gift from actor and sports fan Joe E. Brown. The trophy was engraved to "A Grand Old Timer." The photograph was taken a few days before the legendary ballplayer celebrated his 75th birthday in his favorite manner, quietly at home with his family.

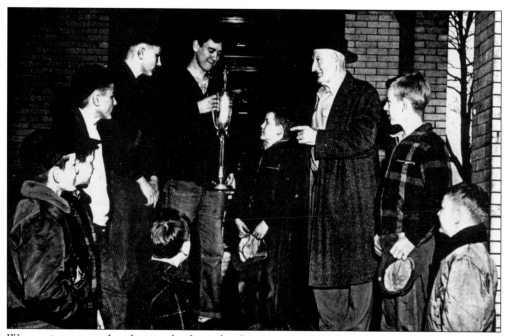

Wagner is presented with a trophy from the Carnegie Boys' Club around the mid-1950s. Famed for his playful nature and penchant for storytelling, the shortstop was loved by the neighborhood boys, to whom Wagner sneaked treats like potato chips and candy at the back door of the Carnegie Elks Club.

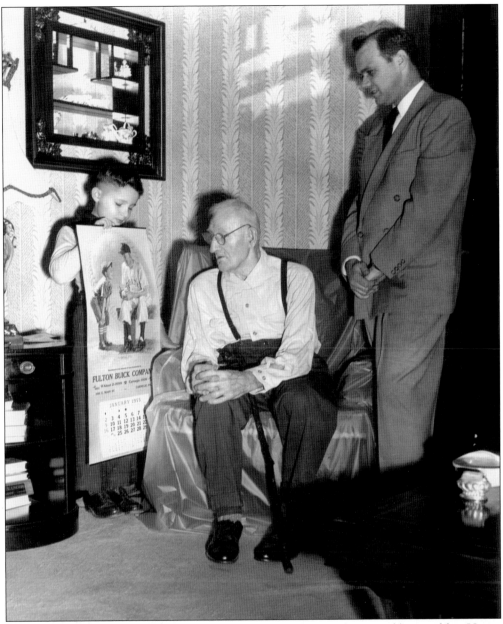

Young Jerry Sgro and Al Fulton unveil *Great Day*, a rendering of Sgro and his neighbor Honus Wagner depicted on a calendar. Famed pinup artist Bill Medcalf rendered several series for Brown and Bigelow, including *American Boy* and *The Baseball Hall of Fame*.

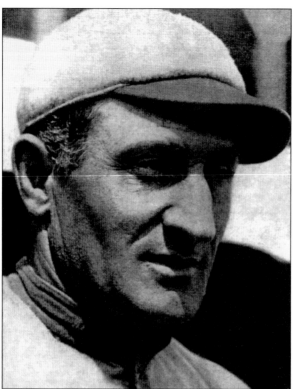

The nation mourned baseball's most revered shortstop when he died in his sleep on December 6, 1955. The Flying Dutchman was 81. Honus Wagner had been sidelined by a fall in his Carnegie home several weeks before and passed peacefully with Bessie and his family at his bedside.

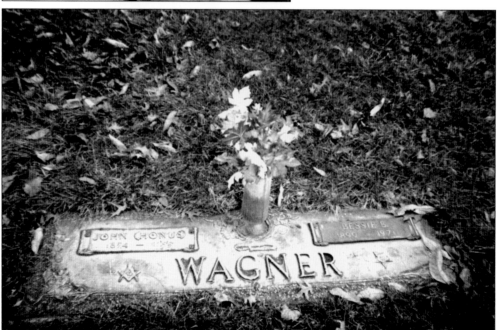

Wagner was laid to rest in Pleasant Hills, Pennsylvania. Wagner's modest family plot, located in the Garden of the Cross, belies the fame and notoriety he enjoyed during his lifetime. The Garden of the Cross receives visitors from all over the world who come to pay their respects to the humble hero.

Eight

NATURAL DISASTERS

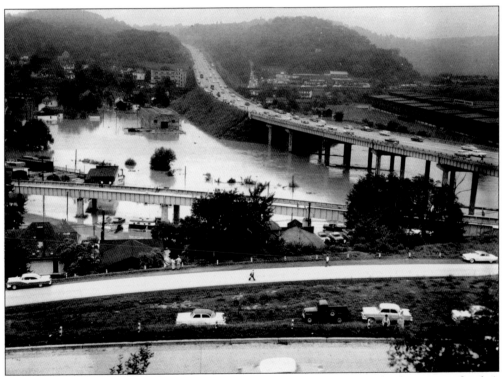

The summer of 1956 was a wet and rainy season, as the town experienced a devastating flood. A steady downpour of rain that began on the evening of August 5 made Main Street impassable and caused Chartiers Creek to spill over its banks. The damages from the 1956 flood were estimated at a staggering $6.2 million.

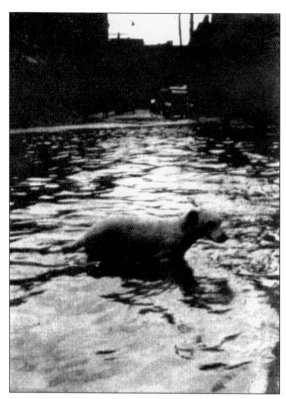

This scruffy, determined canine dog-paddles to what he hopes is the safety beyond the flooded sidewalks as the waters rise in 1936.

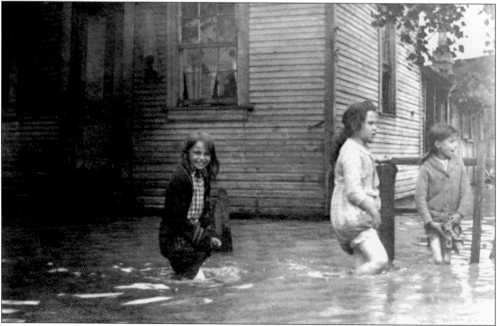

Carnegie was the recipient of nature's fury on dozens of occasions. Flooding has always been a chief concern for the townspeople who were forced to contend with Chartiers Creek when it overflowed its banks. Still, the dampness of the 1936 downpour does not put a damper on the spirits of these Carnegie schoolchildren.

In the summer of 1967, Chartiers Creek appears tranquil and nonthreatening in this photograph depicting the new bridge.

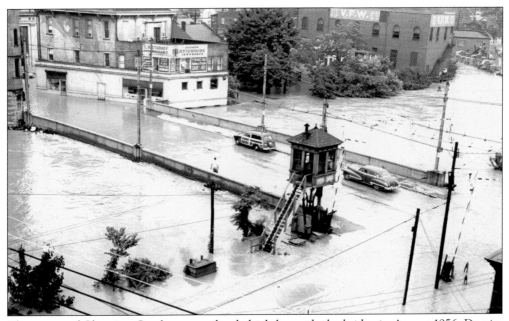

The waters of Chartiers Creek rose perilously high beneath the bridge in August 1956. Despite the redevelopment and the Flood Control Project, the creek overflowed dozens of times in the past 100 years, proving a bane to Carnegie residents and businesses.

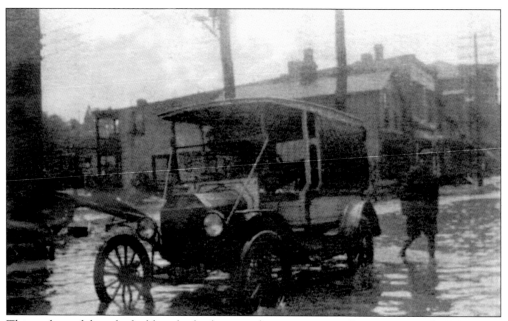

This early model car looks like a bathtub toy as the waters rise in Carnegie around 1920.

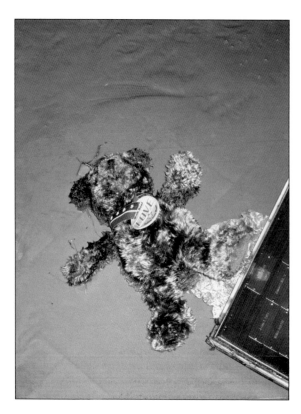

This child's toy is a sad reminder of the devastation Carnegie suffered in the aftermath of Hurricane Ivan on September 17, 2004. But the Love button affixed to the teddy bear's chest provokes a smile.

Fifteen inches of fresh snow blanketed the Carnegie area on January 31, 1966. Fifth Avenue appears slick but passable several days later.

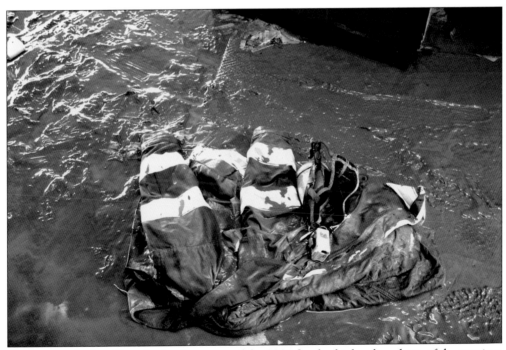

A rescue worker's uniform lay in the waters of the 2004 flood, which eclipsed any of the previous floods in the town's history. At the time of this writing, many residents were still struggling to recover and rebuild, and many businesses and area churches closed their doors for good.

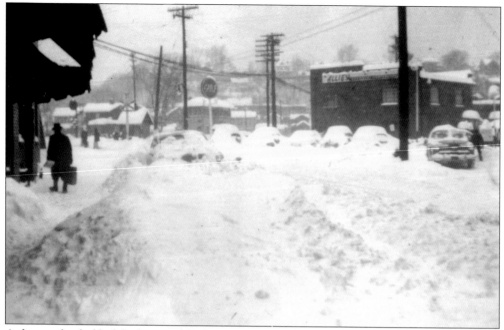

A foot and a half of fresh snow blanketed the area in November 1950. Schools were closed for the Thanksgiving holiday, and sledding and tobogganing were the favorite activities of the vacationing students.

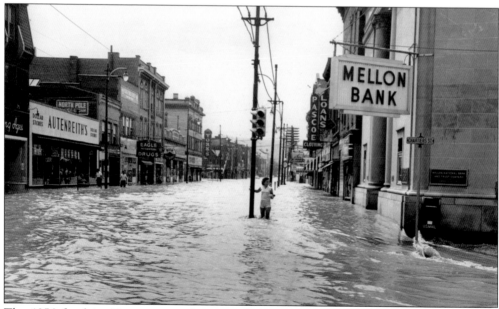

The 1956 flood in Carnegie was the most devastating of the 20th century. However, the pedestrians depicted here appear unfazed as the rushing waters rise on East Main Street.

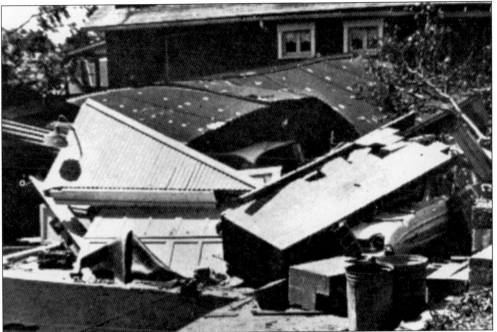

This building was reduced to rubble after the 1963 tornado tore through Carnegie and the surrounding area. It is difficult to determine whether this structure was a home or business.

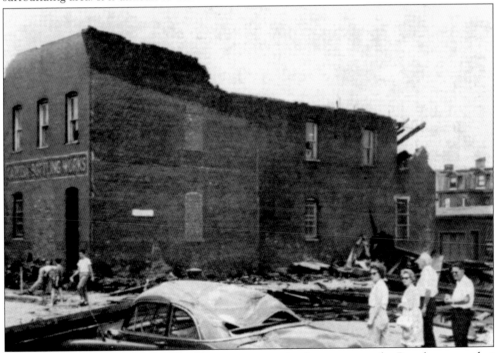

Some recall it as a windstorm, others insist it was a microburst or tornado. But the storm that hit Western Pennsylvania in August 1963 destroyed homes, vehicles, and businesses. This group surveys the damage to this car parked at the bottling plant, whose roof was sheared off by the wind's tremendous force.

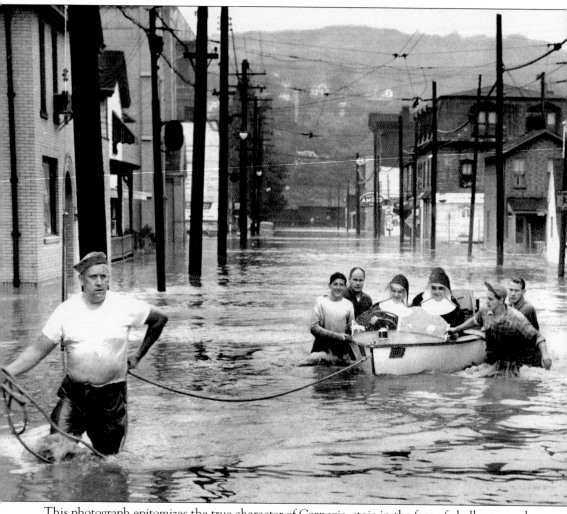

This photograph epitomizes the true character of Carnegie, stoic in the face of challenge, ready to lend a hand, and sustained by faith, as this group heads for higher ground during the flood of August 1956. Pictured are Sister Reginald and Sister Wilma from St. Joseph convent on Second Avenue, Elmer Spratt, Johnny Pointer, Billy Roach, Thomas Roach, Jim Herman, and Bob Crewl.

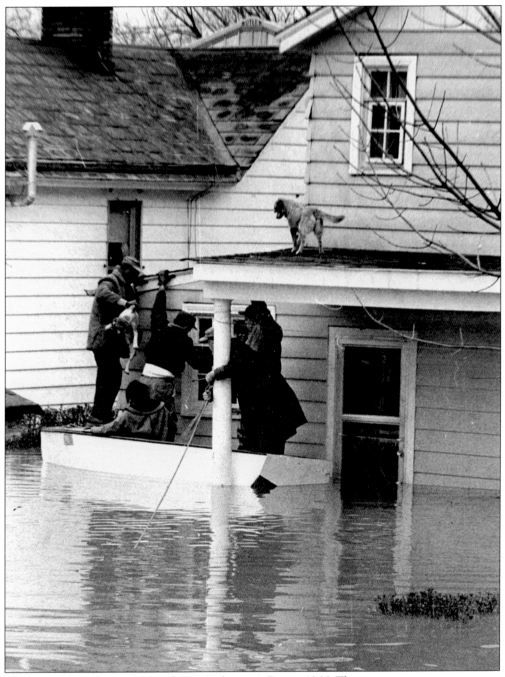

The town of Carnegie celebrated a wet Valentine's Day in 1966. This compassionate rescue team rowed this frightened family to safety and saved their beloved pets, as well.

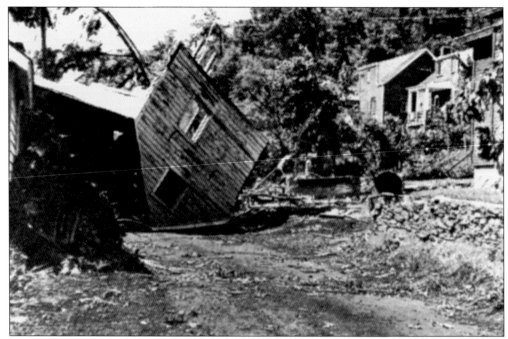

Tornado-force winds leveled homes and businesses in August 1963. This home rests on its roof following the late summer storm.

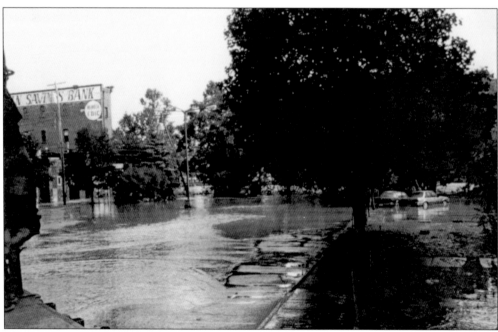

The streets were treacherous when Carnegie was hit with the remnants of Hurricane Ivan on September 17, 2004. Nearly a foot more rain fell on that day than in the 1956 flood, resulting in the closure of many long-standing businesses and churches. Tragically, one Carnegie resident who was hearing-impaired drowned.

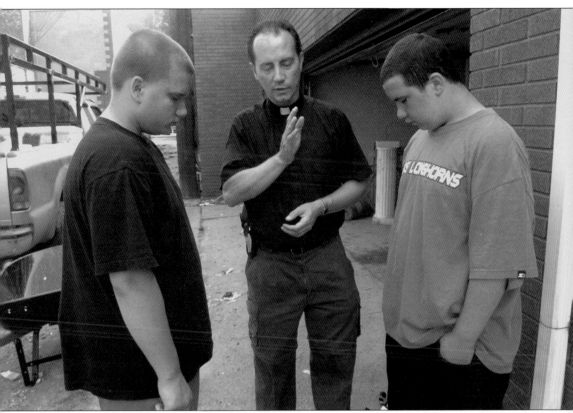

On September 17, 2004, Rev. Joseph Luisi, known as Father Joe of St. Elizabeth Ann Seton parish, donned his scuba gear and rushed to the aid of two teens outside the rectory. Frank Steele Hunter Jr. and Brandon Rush, both 14, were yelling for help as they struggled in the strong current. Luisi saw the boys about 50 yards away but was unable to reach them on the first attempt. He calmed them by praying and telling them jokes, then when he reached them, the three joined hands and held fast to a clump of shrubs. Some 45 minutes later, two rescuers from Johnstown pulled the exhausted trio into their boat. (Copyright, Pittsburgh Post-Gazette, 2006, all rights reserved. Reprinted with permission.)

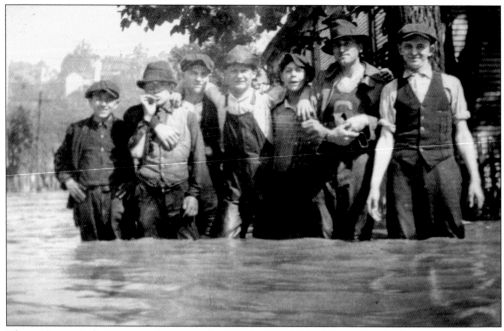

These Carnegie boys appear happy and ready for a swim in Chartiers Creek as the waters rise to waist height.

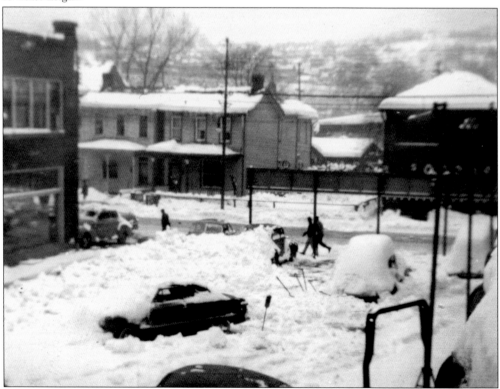

Cars are completely buried in yet another blizzard, resulting in snow days for schoolchildren and an abundance of frustration for those doing the shoveling.

Nine

PERSONALITY PARADE

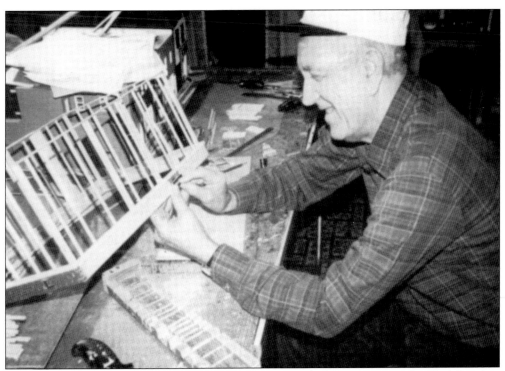

Walter R. Stasik retired from an active, busy career in 1989. He promptly filled his days painstakingly recreating Carnegie in miniature. Working from memory as much as from photographs and research, Stasik spent several years perfecting his miniature hometown, which was on display at the historical society until fire and flood threatened the grand old building. Stasik's masterpiece is currently in storage but will be displayed in the Husler Building window again soon.

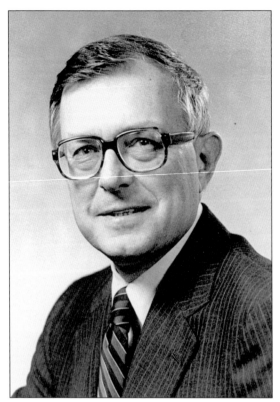

Publisher James W. Knepper Jr., pictured here in March 1986, actively served the people of Carnegie for many years. The Knepper family was the source for Carnegie news for more than a century, and James Knepper served as one of the presidents of the Knepper Press Corporation. The family produced several newspapers, including the *Mansfield Item* and the *The Signal Item*, the latter sold in the early 1990s to Gateway Publications. Knepper's other affiliations include the Greater Pittsburgh Guild for the Blind, Chartiers Area Chamber of Commerce, Andrew Carnegie Free Library, and the Carlynton School Board, among many others.

The tallest man in Carnegie was Shriner Robert B. Keenan, who grew to seven feet and one inch and 404 pounds. Keenan was born in 1894, just as Carnegie was founded. He passed away in 1935 at age 42.

Employee Patricia Porter tends the kitchen at La Cabaret Restaurant and Lounge around 1991.

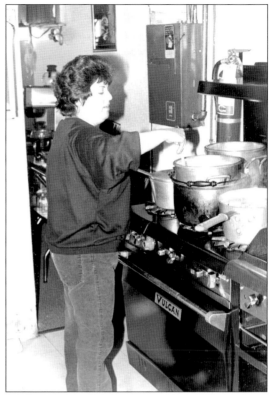

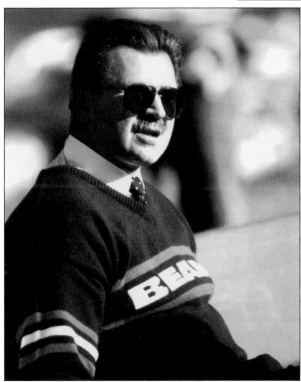

Michael Keller Ditka, known as "Iron Mike," was born in Carnegie on October 18, 1939. He played punter and tight end for the University of Pittsburgh football team. Ditka was the first tight end ever inducted into the Professional Football Hall of Fame (1988). Although he has successfully worked in broadcasting and is a colorful, recognized personality, Ditka is best known as the head coach of the Chicago Bears.

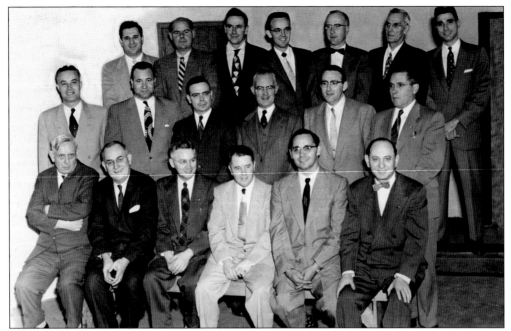

Members of the Carnegie Kiwanis Club gather for a group photograph in 1954. Founded in 1915, the club is a global organization dedicated to serving the community and its children through a variety of programs that address such issues as pediatric trauma and child safety, youth recreation, and civic responsibility.

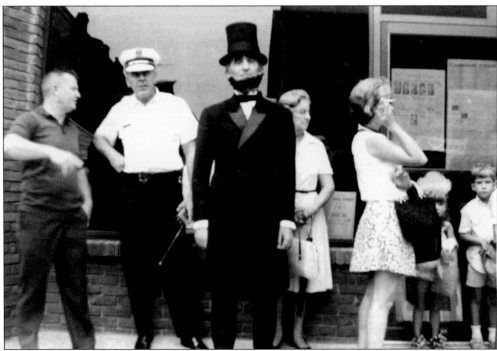

Saul Lipman portrayed Abraham Lincoln at Carnegie's Diamond Jubilee in August 1969. Behind Lipman are police chief Steve Popivchak and Capt. Harry Smith.

The Yankee Harmony Four were quite harmonious in 1910. From top to bottom are Joe Schulte, tenor; Roy Cattly, baritone; A. Krasaur, lead; and John Theinel, bass.

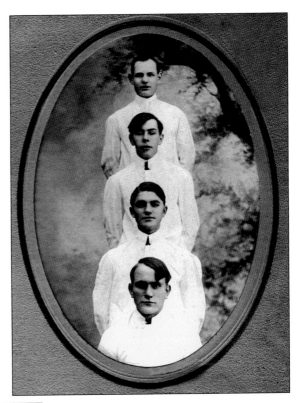

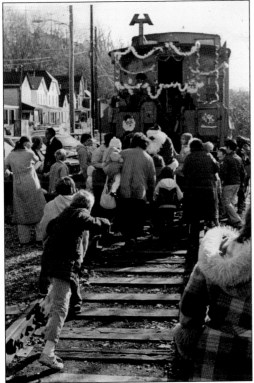

Families eagerly anticipate the arrival of Santa and Mrs. Claus by way of the Santa Train in 1984. Children shared their Christmas wish lists and received treats from jolly St. Nick. And all the visitors were given the opportunity to meet the Conrail crew and explore Santa's car.

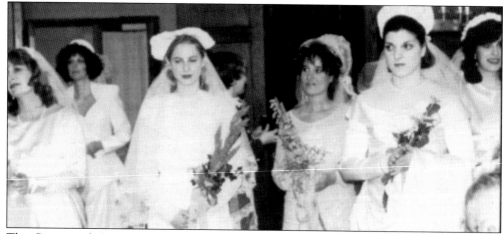

The Centennial Committee of Carnegie hosts a fashion show featuring new bridal gowns, as well as vintage dresses worn by Carnegie brides more than 100 years ago. In fact, 5 of the 27 dresses were older than the town, dating back to 1880. The gowns were custom tailored and repaired by professional seamstress Ann Miraglia, whose own 1935 wedding dress was modeled by Madonna Mullin.

BRIDAL AND VINTAGE GOWN SHOW

DATE WORN	GOWN FIRST WORN BY:	GOWN MODELED BY:
1880	Sarah Cubbage Hosack	Ashley Thompson
1880	Francesca Mendola	Kristyn Bryan
1885	Elise Dickenson	Melissa Shutt
1885	Mary A. Baker Weinstein	Brittany Babish
1890V	Leona Springsted	Gwen Cartier
1910	Josephine Tretter Lechner	Jennifer McCaffrey
1913	Josephine Mendola	Jackie Mendola Lucci
1913	Jennie Paluse	Tina Guarnaccio
1918	Louise Daube Herman	Lynn Cannon
1920V	Ella Mae Haudenshield	Judy Davis
1920V	Ella Mae Haudenshield	Mary Malysko
1923	Jennie Butera Scisciani	Colleen Manna
1924	Laura Scott Haudenshield	Heather Burne
1924	Louise Camaioni	Nicole Camaioni
1928	Mary Speranza	Sue Palonbi
1930	Frances Garner Ditter	Courtney Lynch
1934	Bridget Schiavi	Angela P. Miller
1935	Ann Magliocca Miraglia	Madonna C. Mullin
1939	Amanda DeFonso	Melissa Cartier
1940	Marie Nicolussi Sgro	Colleen Meise
1942	Lillian Nicolussi Coll	Lisa Nicolussi
1946	Marsha Epstein	Melissa Rea
1947V	Mary Burke Haudenshield	Helen Burne
1947	Marie Chiodo Kinzler	Dana Stump
1960	Marianne Cummings	Brenda Bredenback
1964	Maria Colangelo	Alicia Guarnaccio
1969	Josephine Lechner	Jennifer McCaffrey

This list from the bridal show program details both the history of the vintage gowns and the models who showed the dresses on the runway.

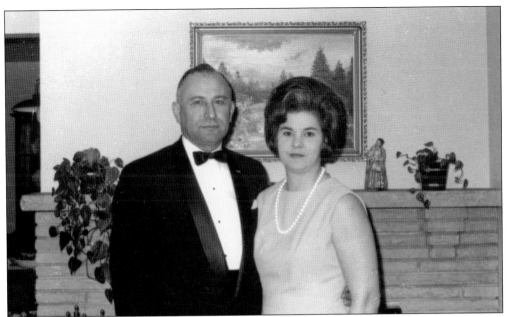

Honor is a word long associated with John Brosky, who proudly served in World War II and enjoyed a distinguished military career in both the U.S. Army and Air National Guard. He then went on to become the Honorable John G. Brosky, superior court judge of Pennsylvania. The jurist lives in Scott Township with his wife, Rose. The pair married on June 24, 1950, shortly before this photograph was taken.

Catherine Cunningham Manion and husband Ernest Ewing Manion served Carnegie in a variety of civic capacities. Ernie was the Carnegie Democratic Party Chairman from 1942 until his death in 1964. He was Carnegie's mayor at that time and played a key role in the town's redevelopment. Catherine, also active in local politics, was the Carnegie Chamber of Commerce's first Woman of the Year in 1974.

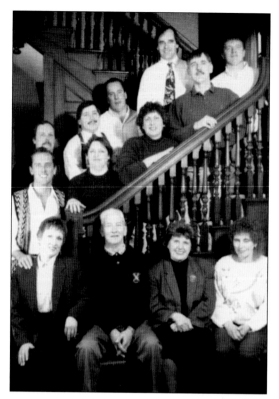

Daniel J. McGrogan Jr. was born on March 23, 1924. An army veteran, he married Marcella Herman, a high school classmate, in April 1945. They had seven sons and four daughters, pictured here. McGrogan served as president of the Carnegie Parking Authority and Civil Service Board. Retired from the University of Pittsburgh, Marcella has been the president of the Historical Society of Carnegie since its inception in 1990.

The late Vic Polk photographed Carnegie for more than 50 years. It is estimated that he snapped 35,000 senior pictures and 3,000 wedding parties. Polk was the photographer of choice for Tony Dorsett when he received the Heisman Trophy in 1976. The photographer met the athlete when he snapped his yearbook photograph at Hopewell High and gifted the family with the pictures when he learned they were financially unable to purchase them.

The ladies from the Steinmetz family bakery show off a cake from their shop around 1970. The bakery was a tradition for generations of area families and served as the first point of contact for brides-to-be planning their receptions.

The Brotherhood of Locomotive Firemen and Enginemen celebrate at a banquet on November 3, 1963.

Mother Nature showed a modicum of mercy as families turned out for the Halloween promenade around 1970. Although the streets were still a bit soggy, the rains subsided in time for the costume parade, an annual tradition that passed through downtown Carnegie.

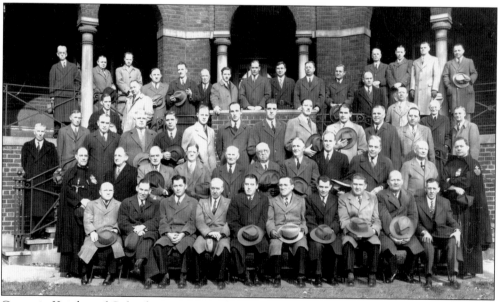

Carnegie Knights of Columbus participated in an advent retreat of state, district, and council officers in December 1941. The event was held at St. Paul's Retreat House in Pittsburgh. The Catholic men's association was founded in New Haven, Connecticut, in February 1882 and has long been dedicated to promoting Catholic education and charity, particularly to and for children. Rev. Linus Monahan (second row, far left) served as the retreat master and Rev. Romuald Walsh (second row, far right) was the acting retreat director.

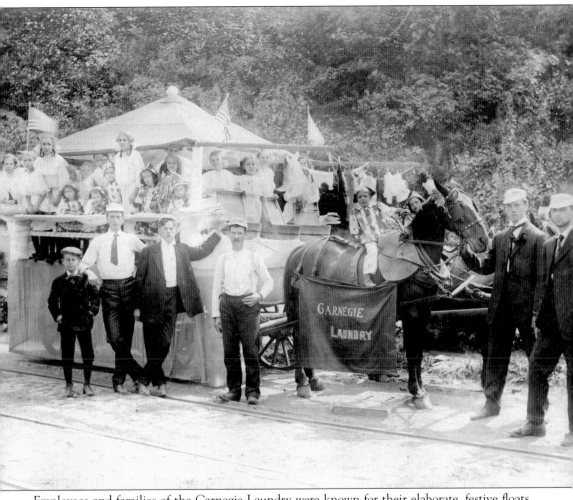

Employees and families of the Carnegie Laundry were known for their elaborate, festive floats in the early 1900s. Here the company's decorated wagon passes down Main Street during Old Home Week in August 1908.

Parades are a long-standing tradition in Carnegie, as residents welcome the opportunity to celebrate and herald their heroes and holidays in a big way. These revelers enjoy a ride in the St. Patrick's Day parade in 1906.

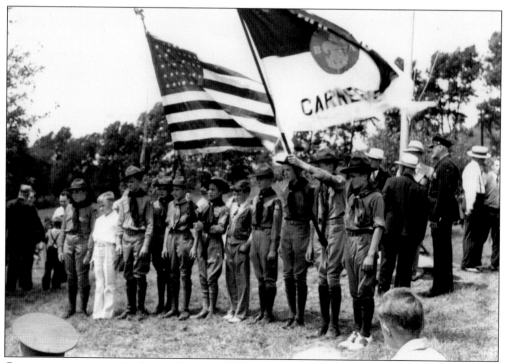

Carnegie scouts raise the flags at Carnegie Park. The afternoon's activities included an archery demonstration and competition.

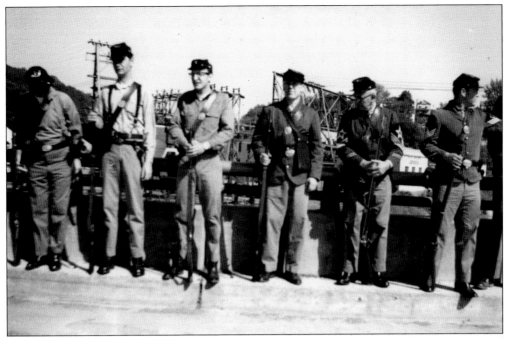

The Civil War Detachment, rifles in hand, assemble on the bridge during the 1970 Memorial Day parade.

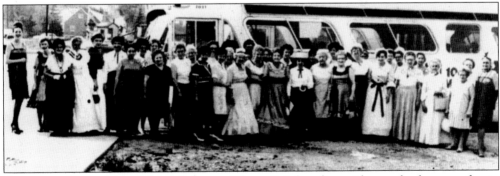

Carnegie celebrated the 75th anniversary of the town's founding with a week of summer fun in August 1969. Residents were invited to dress in period costume for the Diamond Jubilee Week events, which included Merchants' Bargain Days, a food bazaar, craft demonstrations like rug looming and embroidery, and a theater production, *Revival in the Rich Valley*. Here the Mansfield Dollies board the bus for a "Night at The Meadows" racetrack.

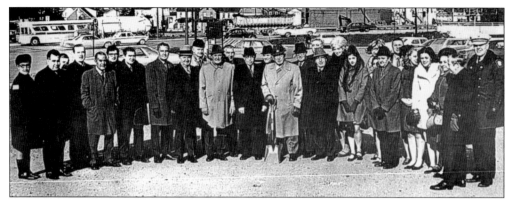

This committee convenes for the groundbreaking ceremony of a stage in the redevelopment process in January 1971. The redevelopment plan was a multi-pronged initiative that called for the widening of Jane Street (later Mansfield Boulevard), construction of a new bridge, and flood control, which was effected the following year.

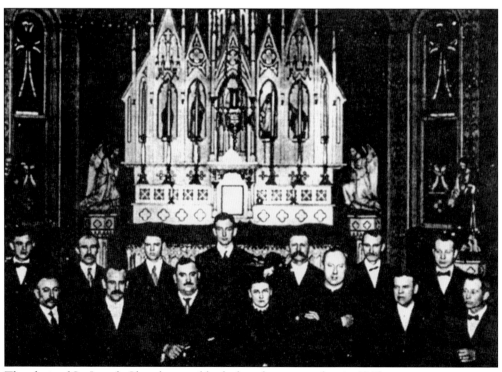

The choir of St. Joseph Church assembles before the ornate altar in 1908.

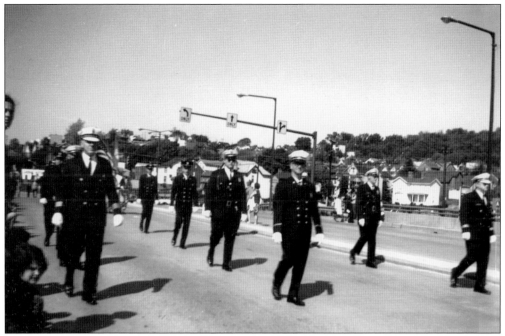

Signs of progress and development are evident as cobblestone streets are replaced by a multi-lane highway in 1970. Uniformed officers from the police and fire departments march on Mansfield Boulevard during the Memorial Day parade.

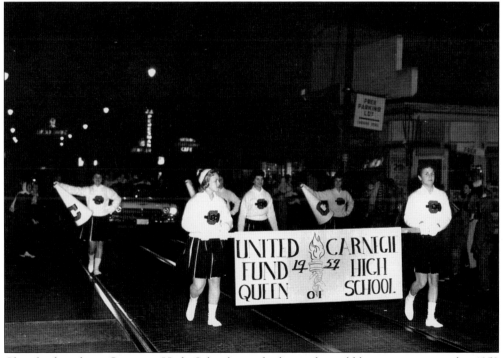

Cheerleaders from Carnegie High School march down the cobblestone street in the 1959 Christmas parade. Pat Caruso, right, was named United Fund Queen.

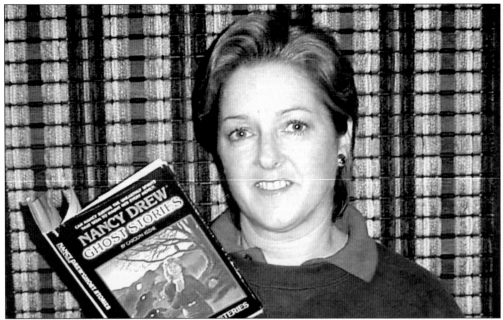

Cynthia Adams Lum poses with her short story "Ghost Dogs of Whispering Oaks" from a collection of Nancy Drew ghost stories. Lum's great grandfather, Edward Stratemeyer, created Nancy and wrote the first four Nancy Drew mysteries. Using 88 different pen names, Stratemeyer created 150 series of books, including Nancy Drew, The Hardy Boys, and The Bobbsey Twins. After his death, his daughters, Harriet Adams (née Stratemeyer) and Edna Squier (née Stratemeyer), continued writing stories such as Nancy under their father's Stratemeyer Syndicate, as it was then known. Most Nancy Drew readers know the ghostwriters as "Carolyn Keene." Lum is proud to carry on the family business and is currently penning *The Mysterious Stratemeyers*. She lives in Carnegie with her three dogs.

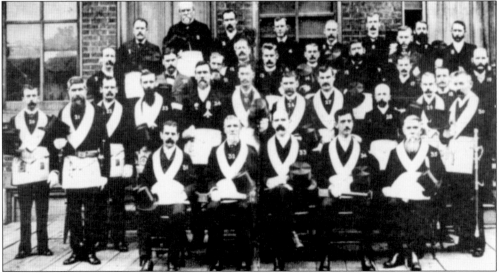

Members of the Centennial Lodge No. 544 of the Free and Accepted Masons convene in 1888. Established in 1876, this lodge was called Centennial to commemorate the first century of the United States of America. The Carnegie Masons are part of the world's largest fraternal organization.

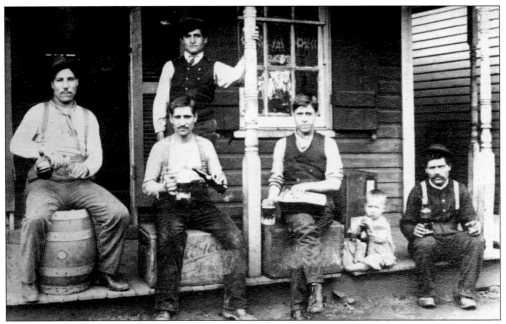

This crew winds down the end of a grueling work week with a round of beers, possibly brewed at their own Chartiers Valley Brewery. Hopefully the toddler pictured here was enjoying a sarsaparilla.

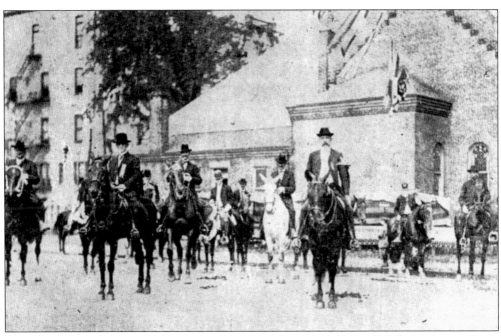

Several of Carnegie's most prominent citizens celebrate Old Home Week in August 1908. Photographed here on horseback are Dr. E. G. Husler, L. H. Walter, W. M. Cole, B. McDermott, William J. Irvin, Dr. J. H. McKee, P. McDermott, W. H. H. Lea, J. Carlisle, and Samuel Gamble.

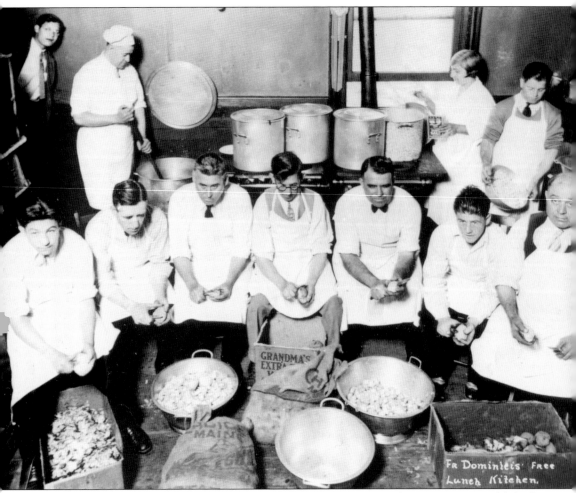

Fr Dominicis' Free Lunch Kitchen.

During the Great Depression, Holy Souls' beloved pastor, Fr. Ercole Dominicus, established a soup kitchen to feed Carnegie's poor. It was a daunting undertaking that required a stocked pantry and many dedicated workers and volunteers. Here, the staff at Father Dominicus' Free Lunch Kitchen peel dozens of potatoes in preparation for the hot lunchtime meal, which always drew a big crowd.

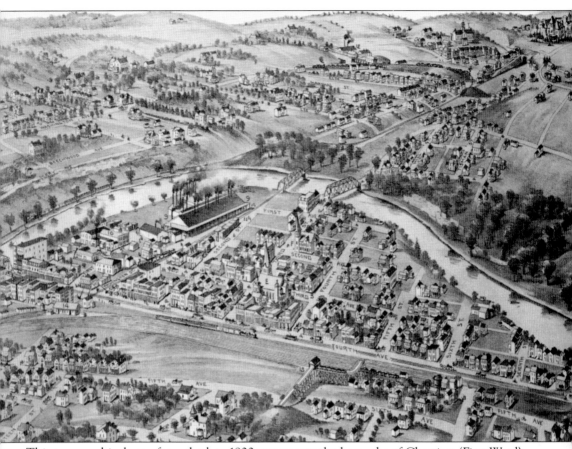

This topographical map from the late 1800s represents the boroughs of Chartiers (First Ward) and Mansfield (Second Ward). The boroughs, which merged to become Carnegie in 1894, were divided by Chartiers Creek.

ACROSS AMERICA, PEOPLE ARE DISCOVERING SOMETHING WONDERFUL. *THEIR HERITAGE.*

Arcadia Publishing is the leading local history publisher in the United States. With more than 3,000 titles in print and hundreds of new titles released every year, Arcadia has extensive specialized experience chronicling the history of communities and celebrating America's hidden stories, bringing to life the people, places, and events from the past. To discover the history of other communities across the nation, please visit:

www.arcadiapublishing.com

Customized search tools allow you to find regional history books about the town where you grew up, the cities where your friends and family live, the town where your parents met, or even that retirement spot you've been dreaming about.